GREENOCK
& GOUROCK
THROUGH TIME
Bill Clark & Gaie Brown

AMBERLEY PUBLISHING

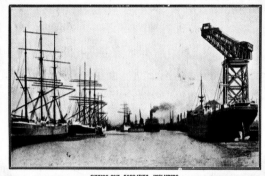
First published 2012

Amberley Publishing
The Hill, Stroud, Gloucestershire, GL5 4EP
www.amberley-books.com

Copyright © Bill Clark & Gaie Brown, 2012

The right of Bill Clark & Gaie Brown to be identified as the Author of this work has been asserted in accordance with the Copyrights, Designs and Patents Act 1988.

ISBN 978 1 4456 1016 0

British Library Cataloguing in Publication Data.
A catalogue record for this book is available from the British Library.

Typesetting by Amberley Publishing.
Printed in Great Britain.

Introduction

It is very easy to forget. Today, we are used to continually changing urban landscapes in which buildings come and go with startling rapidity and road systems are altered to satisfy the insatiable need for rapid personal transport. Our memories of past landscapes quickly fade and, though not always impressed by the replacements, we inevitably adapt to them. Given the appropriate stimulus, however, these memories awaken and we may again walk those old paths. At our camera club few things can be guaranteed to promote as much discussion and argument as past images of Inverclyde. The motivation for producing this book is both to record something of our local heritage and to document changes that have taken place (though not necessarily for the better). This is essentially a photographic journey rather than a historical one, as the latter has been well travelled by earlier publications, but a summary of local history is perhaps merited.

The 1857 *Imperial Gazetteer of Scotland* describes Greenock at the beginning of the seventeenth century as a 'mean fishing village consisting of a single row of thatched cottages'. This was to about to change, however, and in 1681 the town became a free burgh of barony by charter granted by John Shaw, with a weekly market and two annual fairs. Thereafter, fishing increased, peaking at a fleet of 900 boats. A harbour was completed in 1734, the largest of its kind in Scotland at that time, which greatly increased both trade and population. More harbours and dry docks followed; 'these works are as commodious and elegant as any in the kingdom, with depth of water sufficient for the largest class of vessel'. Greenock prospered, with a shipping trade at one time greater than that of any other Scottish port. The provision to the town of water power from reservoirs and courses designed by Robert Thom in 1827 enabled the proliferation of industries such as shipbuilding, iron working, sugar refining, leather tanning, pottery making, cooperage, distilling and brewing. Cotton, flax, wool, grain and dyewood mills existed, as did rope, paper, chemical and soap & candle works – together with sawmills, a biscuit bakery, and even a straw hat factory! Housing varied from the large villas of the west end to the overcrowded houses and narrow alleys of the town centre. The intervening years have wrought many changes in the town centre and east end. Blitz damage to Greenock during the Second World War was considerable. Remarkably, the 245-foot (75-metre) Victoria Tower survived and is still the most prominent local landmark. In the twenty-first century, industries have been replaced by call-centres, shipbuilding is no more and a small shopping mall replaces the high street shops and many cinemas that Greenock once boasted. Some fine old buildings remain, however, and the waterfront and east end are in the process of regeneration. Container ships still discharge their cargoes, cruise ships regularly dock and two 'Tall Ships' events have been hugely successful, filling the harbours once again with elegant vessels.

Gourock is much less altered. Though tourism has declined, the traditional seaside resort still receives day-trippers visiting Gourock Pool, one of only two remaining outdoor, heated salt-water pools in Scotland. The main changes apparent today are the new pier and station buildings. Unchanged, however, is the *Gazetteer* description: 'The view seaward from the town is charming and comprises much diversity; the ground behind rises rapidly and leads up to exquisite Clyde-commanding summits. The whole town is of neat, cleanly and cheerful aspect, with snug, spruce, comfortable abodes and well-built convenient stone-pier.'

It is impossible, of course, to portray all the changes – not least because of the random nature of the survival and availability of old photographs. The book, therefore, contains an eclectic set of past images, though we have attempted to cover the area's better-known aspects. The dates of the early images also vary, from before 1900 to about 1980. We felt it important to include some more recent images of places people may remember, rather than only 'historical' ones. The 'then and now' format employed pairs each image with a modern equivalent from as near the original viewpoint as possible. In some instances we were forced to deviate from this, but we used some ingenuity in finding alternative angles. In fact, we feel that use of such artistic licence has added variety to what could otherwise have proved too rigid a format.

The Authors

Both authors are enthusiastic amateur photographers who are members of Inverclyde Camera Club. Gaie was born and brought up on the Isle of Bute but has spent most of her life in Greenock. She worked in medical research for many years and now works in the Gaelic unit of a local primary school. Bill was born in Fraserburgh but moved to Inverclyde in 1970, after graduating from Aberdeen University. He worked for IBM, in computer software support, for over thirty years. He is now retired and lives in Inverkip.

SECTION 1

Greenock

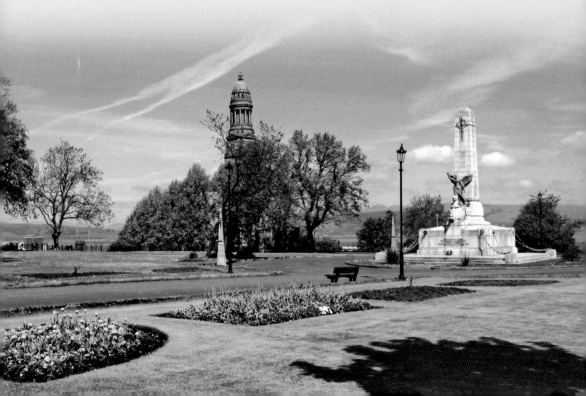

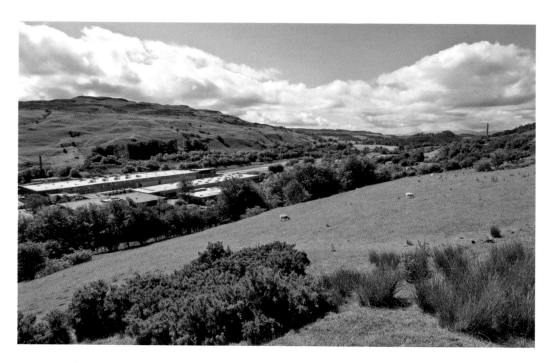

Spango Valley

Today, we are used to the presence of the IBM plant alongside Inverkip Road, where it leaves Greenock, heading south. An early view, however, dating from about 1950, shows how the valley once looked. Only recently it was even more built up, as is shown in the modern view by the brown scar at the southern end of the site, which marks where the IBM MDC (Materials Distribution Centre – an automated warehouse) was demolished in 2009.

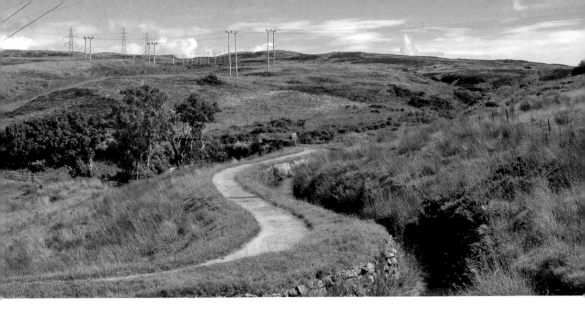

The Cut

The Greenock Cut is a 4-mile-long aqueduct that carried water to the town both for drinking and to provide power for local industries. Built between 1825 and 1827 by Robert Thom, a civil engineer after whom the main reservoir that supplied the system was named, it remained functional until 1971, when it was superseded by a tunnel. In 1972, it was designated as an Ancient Monument and was restored in 2007 using Heritage Lottery funds. The moorlands above Greenock have changed little in the intervening 100 years, but for the march of the pylons.

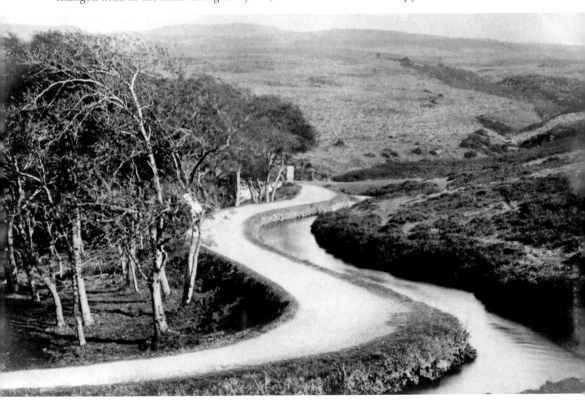

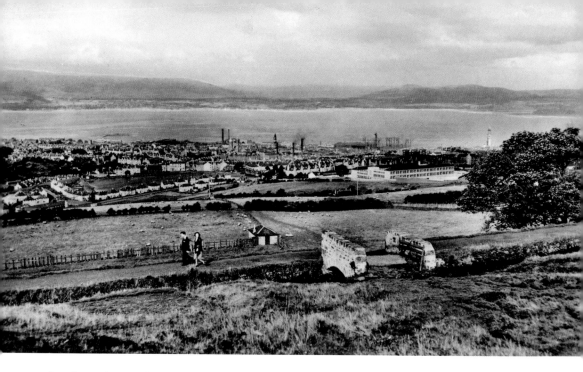

View from the South

From the Cut, a wide vista of the urban areas along the riverside can be seen. An early view from Overton shows little development in the area to the south of Dunlop Street. Today, however, housing completely covers what previously were open fields. The large building right of centre is the original St Columba's Senior High School. The bridge that crossed the Cut at this point has now been removed and only part of the base is visible in the present-day picture.

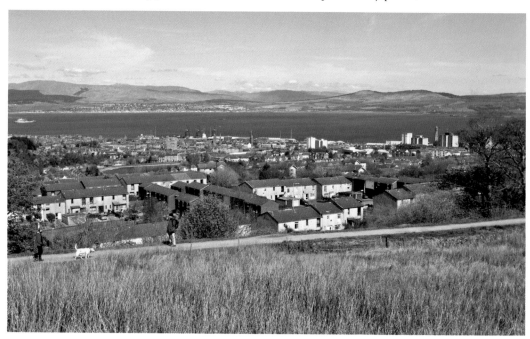

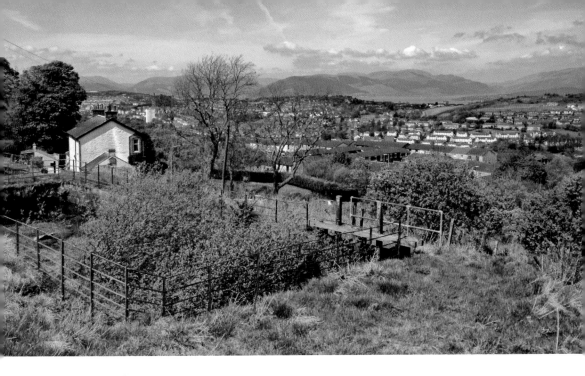

View North from Overton

A modern view from above Greenock shows its expansion to the south-west, where once there were only farms. Above the town lies the Cut, with its complex series of workings that supplied water to the town, and an early view shows the water engineer's house and a regulating basin. Today, the house survives, but the basin has fallen into disuse – now silted up and overgrown. On the right is the Combination Hospital, now demolished, which dates the view to after 1908, when this was built.

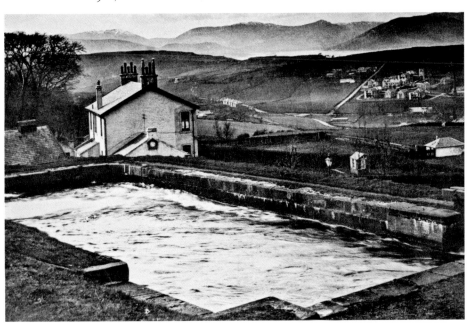

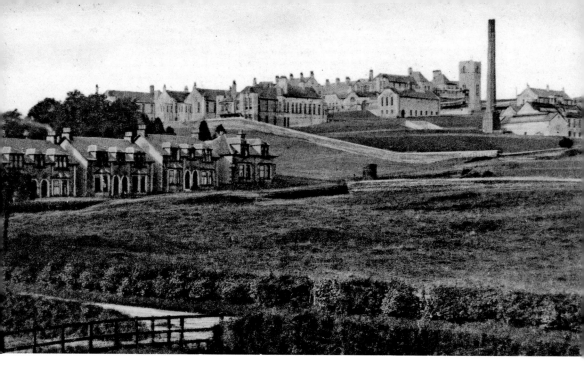

Grieve Road

An early view from 1910 of Grieve Road and the Combination Hospital is impossible to repeat today, as the whole of the foreground area is now built up. The only way to see the changes is from above. The row of houses bottom-left is that in the original picture, which had been taken from the bottom-right corner of the present-day view, opposite where Lady Alice School now stands. The hospital was later renamed Gateside and was closed in 1979. The site is now a housing estate.

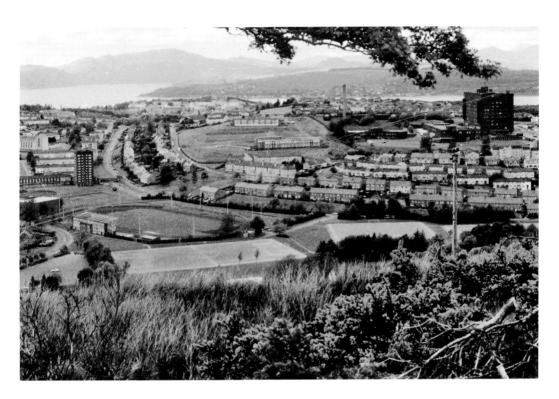

Ravenscraig Playing Fields/Inverclyde Academy
Though this is a fairly recent view, it serves to show one of the latest changes to have taken place locally – the building of a new school, with a capacity of 1,100. Inverclyde Academy accepted its first intake of pupils on 19 December 2008, though Her Royal Highness Princess Anne did not perform the official opening ceremony until 20 February 2009.

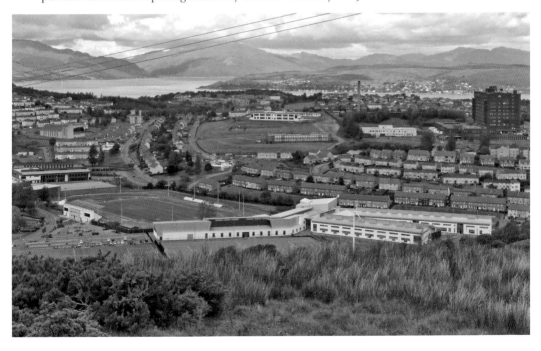

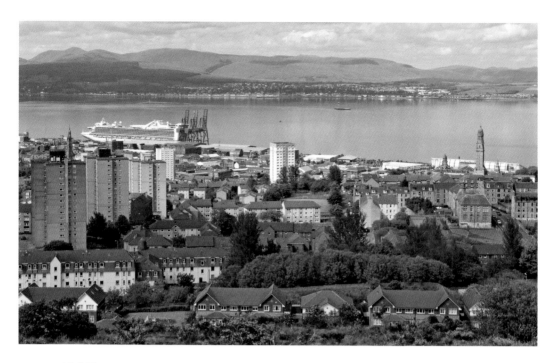

From Whinhill

Today, the view shows a modern town, pollution-free but with little obvious industry. This is in stark contrast to the view in 1880, which shows shipbuilding along the Clyde and pollution from the chimney of a sugar-house on Drumfrochar Road. The modern view has been taken from slightly to the left of the early one and appears wider but, strangely, both are bounded by the St George's North spire on the left and the Mearns Street School on the right.

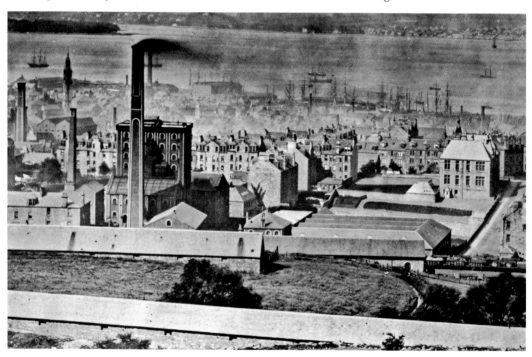

Dunlop Street from Peat Road

The date of this early view is unknown, but is certainly pre-1929 – when Greenock High School was built on the area in the foreground. By the 1970s the school had become Notre Dame High, but this was demolished in 2009 and replaced by an imposing new building completed in 2011. Today, from the original viewpoint, only a small section of Dunlop Street remains visible. Greenock prison provides a starting point from which to establish a visual reference.

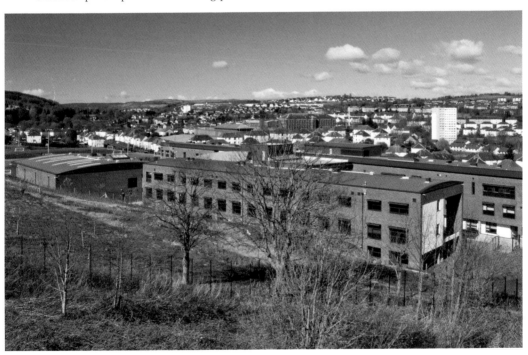

13

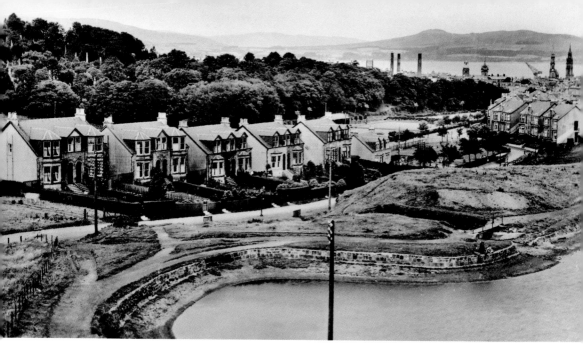

From Lady Alice Park

This was one of the more challenging images to reproduce, as a thick screen of trees now obscures most of the early view from above the town reservoir, overlooking Old Inverkip Road and Lady Alice Bowling Club. Today, the area has to be shown in two parts. The line of houses appears little changed, although there are now many more; the reservoir, shown in an inset, has matured since its bare origins and has become a pleasant little oasis with resident swans and ducks.

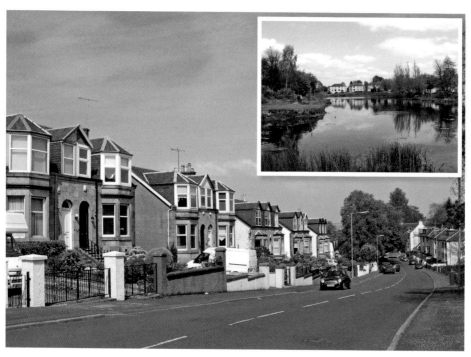

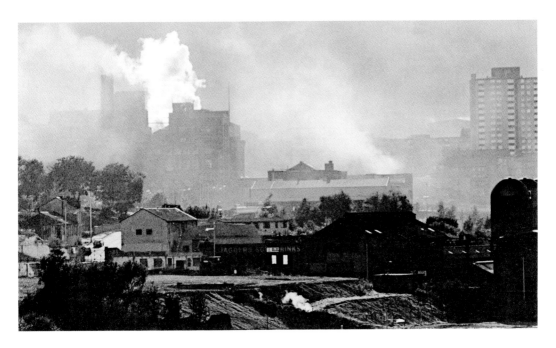

Tate & Lyle Sugar House

Greenock was once famous for sugar and was home to several mills. The last of these to go was the Tate & Lyle mill on Drumfrochar Road near the top of Lynedoch Street, seen backlit in the 1980s. This closed in 1997 and today the site is derelict. Now only parts of the walls remain, among the trees visible to the left-of-centre on the present-day view, as seen from Belville Street.

Inset: Looking east along Drumfrochar Road.

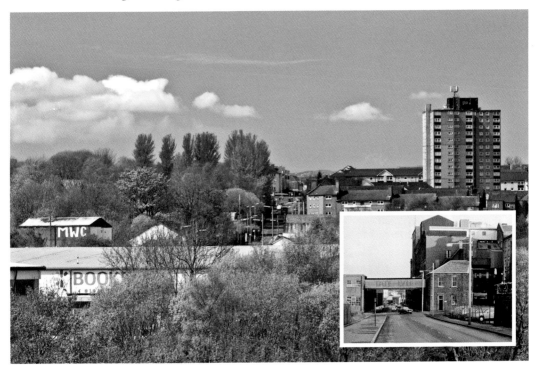

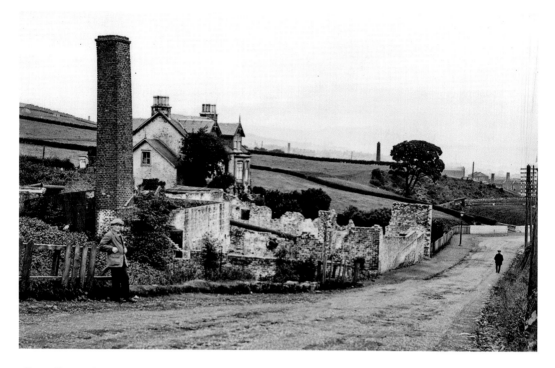

Flintmill Lane/Kilmacolm Road

In 1823, on what is now Kilmacolm Road, a mill was built to grind the flint used by the Clyde Pottery in the manufacture of earthenware. A view from around 1920 shows the ruins of the mill, which was situated on the Cartsburn, near the entrance to Auchmountain Glen. The equivalent view today, looking down towards the town, has changed utterly.

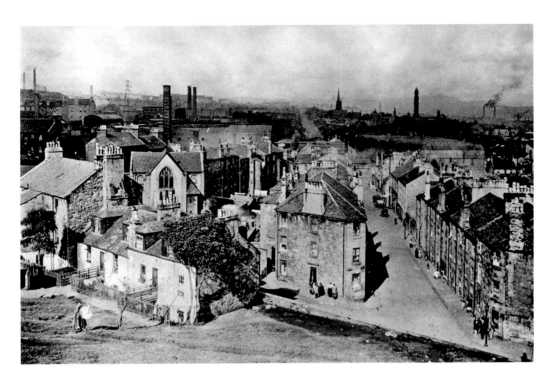

Cartsdyke

This area of the town has changed almost beyond recognition – of the foreground buildings in the early view, none has survived and Saint John Street on the right no longer exists. The church to the left of centre was St Stephen's Episcopal Mission, built in 1907. Only by locating landmarks and aligning on distant Regent Street can a similar present-day angle be achieved, showing a slightly wider view than the original.

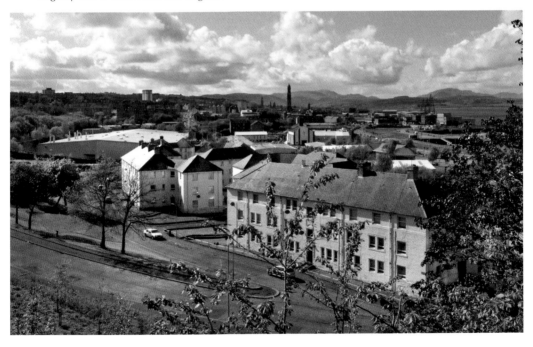

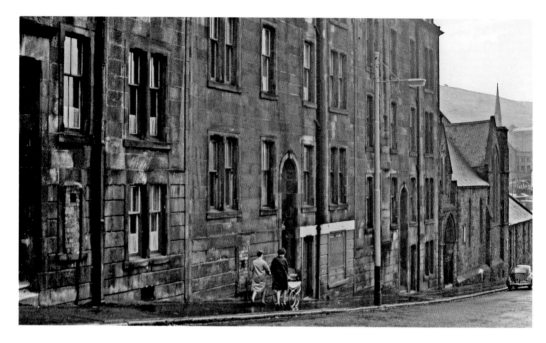

The East End

This region of Greenock has undergone considerable change and regeneration in the last twenty years. Most of the old housing stock has been replaced; there is a new school complex in Blairmore Road; children's play areas have been developed and a sports centre built. The St Lawrence Street tenement houses in a view from 1968 are gone and Cartsdyke Church, just visible on the right of both images, is now derelict.

Morton Terrace

This row of houses on Carwood Street, at its junction with East Crawfurd Street, retains a similar appearance to that of nearly a century ago, except that the chimney heads are shorter and 2 or 3 metres seem to have been cut away from the gable end nearest the camera. Today, a traffic island replaces the original fountain, but this still retains a lamp standard, albeit of a less interesting design!

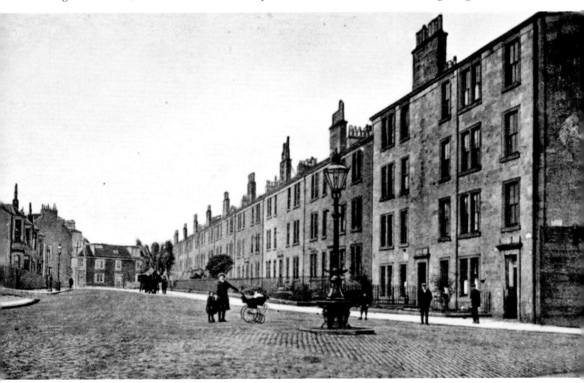

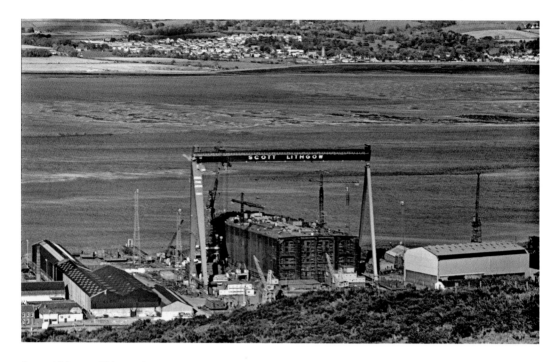

Scott Lithgow Shipyard

Geographically, this area is in Port Glasgow, but the name Scott Lithgow is synonymous with this whole section of the Clyde. With the yard's demise, it is difficult now to see where the Goliath crane stood, but the piers along which the tracks once ran can still be seen. The present-day view is slightly wider than the early one, so that the new houses on the left and the Tesco car park on the right serve as visual reference points.

 Inset: The Goliath crane seen from the Port.

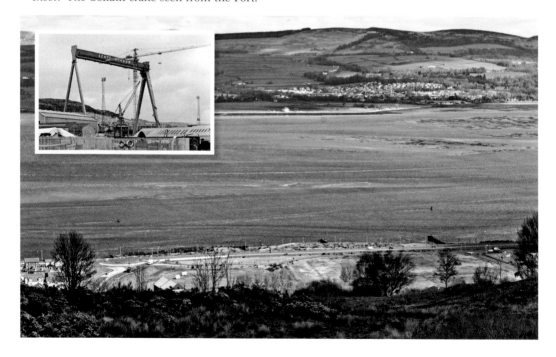

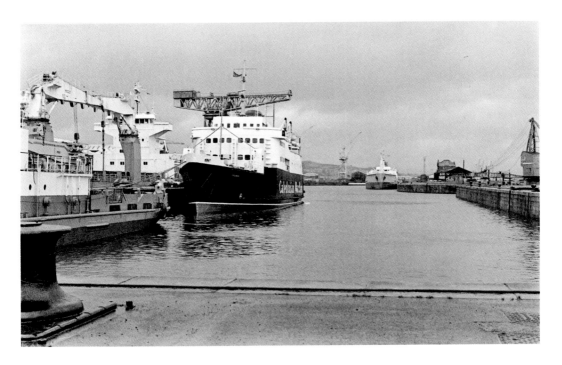

James Watt Dock

Though the early view was taken as recently as the 1980s, the modern version shows that major changes have taken place. An interesting feature is the presence, to the right of a cargo ship in the distance, of Garvel House. This listed building, dating back to 1777, was controversially demolished in 2004. With the demise of the sugar industry, large cargo ships no longer frequent the dock, which is now in the process of being converted for leisure use.

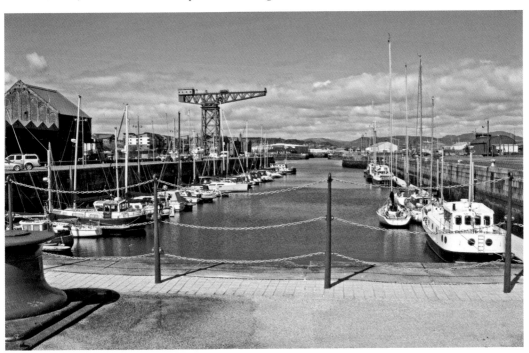

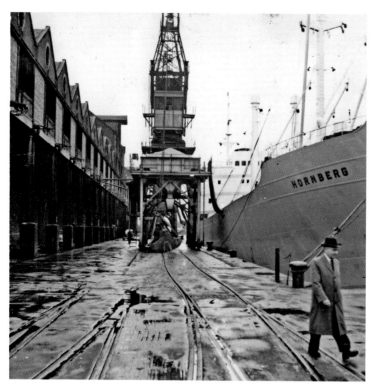

Sugar Warehouse/ James Watt Dock

Sugar refining began in Greenock as early as 1765 and by the end of the nineteenth century there were fourteen sugar-houses in operation. Fronting the James Watt Dock were the sugar sheds, complete with specialised equipment for unloading the sugar boats. The last sugar boat to unload here was the *Fidelity* in June 1992, after which offloading transferred to the Ocean Terminal. Sadly, the last refinery, that of Tate & Lyle, closed in August 1997 and the machinery has left behind, as its legacy, parts of the track where it once ran. The dock has now been converted into a marina and the sheds remain, as they are listed as a fine example of early industrial architecture, with an unusual cast-iron colonnade that formed a sheltered unloading area. In the distance is another listed structure, the Titan crane, constructed in 1917.

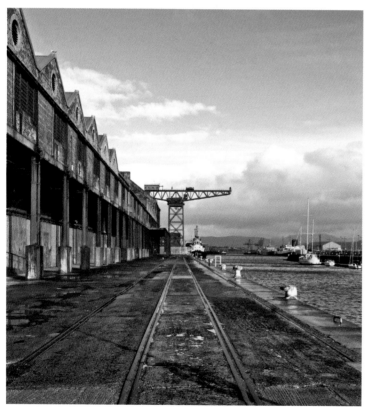

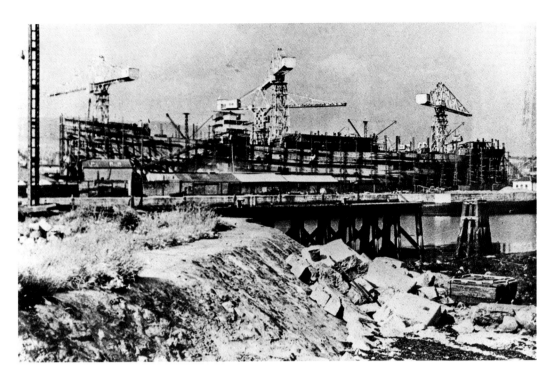

Cartsdyke Shipyard
An early view shows a ship under construction in the Cartsdyke Yard sometime around 1930. Today, the shipyards are gone and it is now hard to visualise where they once stood. In this case, the jetty at the entrance to the dry dock provides a clue and a present-day view from Garvel Point shows The Point restaurant and a Misco warehouse now occupying the former construction site.

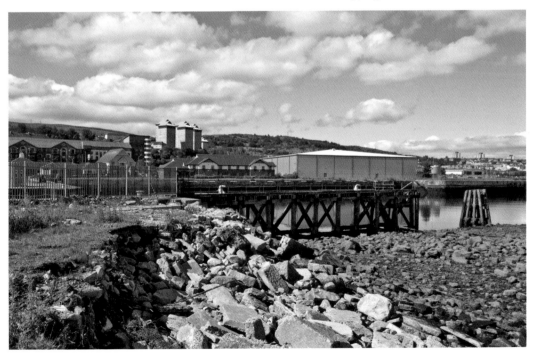

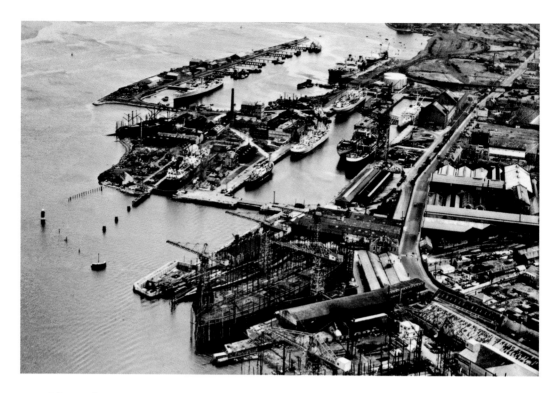

The Yards

An aerial view, looking east towards Garvel Point, shows the Cartsdyke shipyard and Kincaids engine works in 1949. Today, nothing remains of these. The modern view has been taken from a point near the right edge of the early one, looking towards where the slipways once were. The inset picture was taken from near the original James Watt dock gates (centre of the early view), looking back along the jetty on the north side of the slipways.

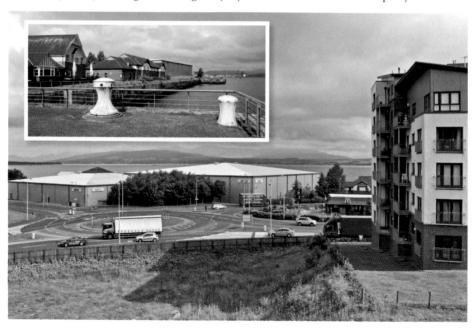

Main Street/Knowe Road Junction

This area now bears no similarity to what it looked like around 1920. Where once stood the 'Lighthouse Tenements', built prior to 1705, there is now nothing more than a grassy bank. Scotts Shipyard, the wall of which is visible on the left, and the cobbled tramway of Main Street in the early view have given way to a busy dual carriageway.

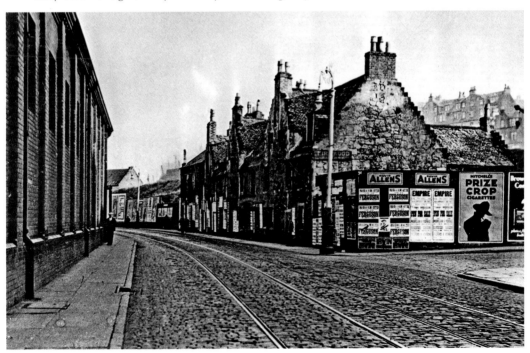

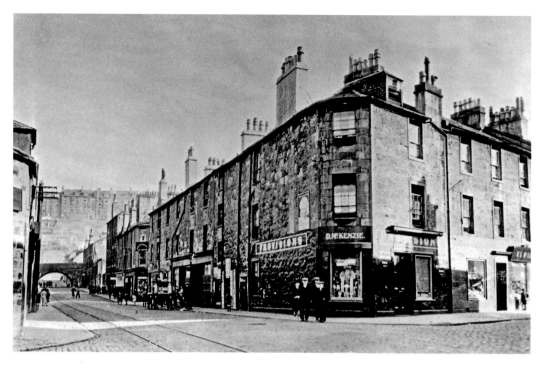

Arthur Street

None of the buildings in an early view looking south along Arthur Street remain – either on the street itself or on Belville Street in the background and the present-day view has changed almost beyond recognition. Only the railway bridge has remained constant and it is the single feature that allows the original viewpoint to be identified.

Inset: A hardware store on Arthur Street during the 1920s.

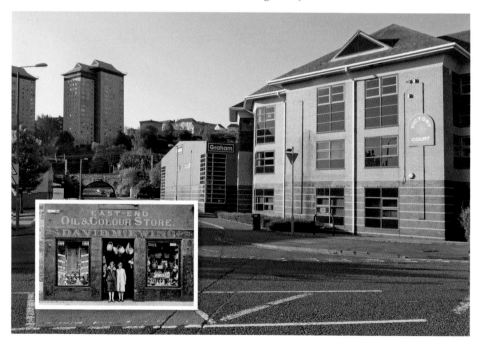

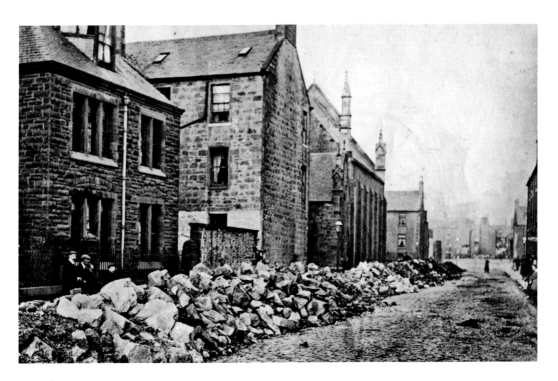

Carnock Street

This early view, labelled 'laying electricity cables near St. Andrews Square', dates from the mid-1920s. The United Free Church, standing just right of centre, identifies this as Carnock Street looking east. The church, which was opened in 1867, was badly damaged in the 1941 Blitz and reopened in 1951. It is the only original building which still exists – though the roadway itself is one of the few that retains its original cobblestone surface.

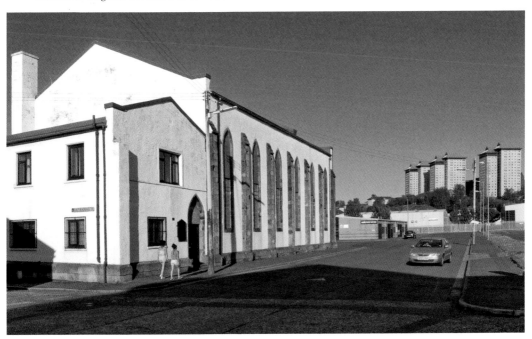

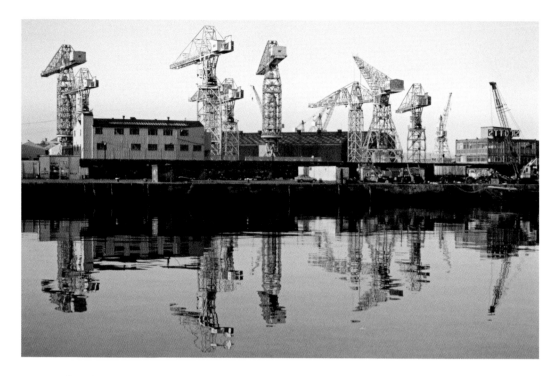

Across Victoria Harbour

As late as 1990, the skyline to the east of the Victoria Harbour was still dominated by derricks and cranes. Shortly after, however, these were brought down and the yards were cleared. A slightly wider view across the harbour today shows a huge change. The only surviving crane, the Titan at the James Watt Dock further upriver, is visible behind the T-Mobile building.

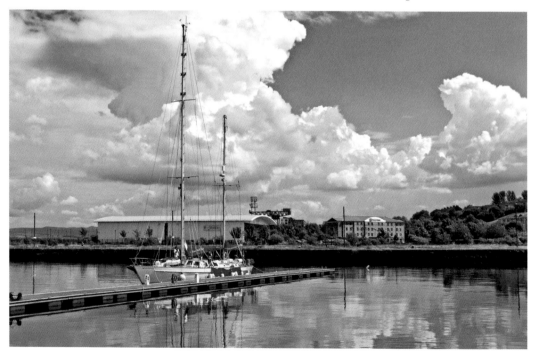

Kincaids

A view from the Victoria Harbour, dating from the 1970s, shows the John G. Kincaid engine works. Kincaid had been born in Greenock in 1840 and the company bearing his name existed from 1895, when it was formed from the Hastie, Kincaid & Donald company. Kincaid died in 1924 but for decades his name remained synonymous with quality marine engines. Sadly, engineering shared the same fate as shipbuilding, so no new ships will make the proud boast, 'Engined by Kincaid'. The large building shown in the picture was built in 1953, but the works was demolished in 2002 and the present-day view shows the HEROtsc contact centre now occupying the site.

Inset: A 1948 magazine front-page advertisement for Kincaid.

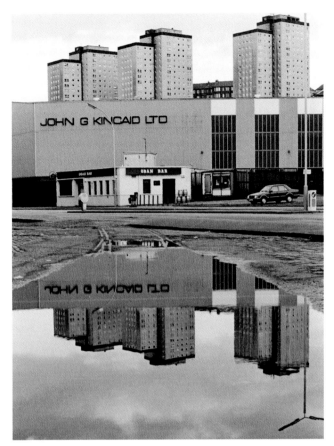

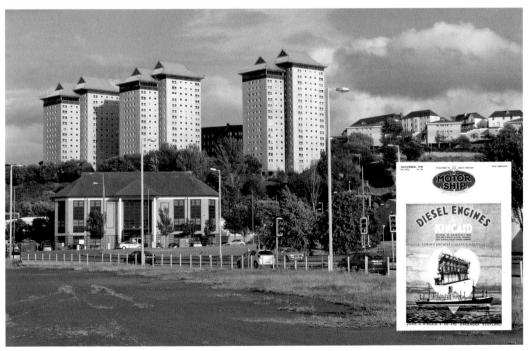

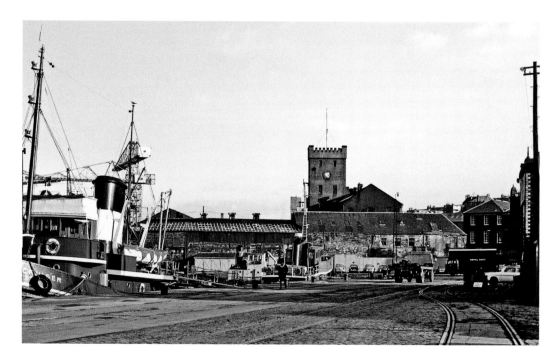

Victoria Harbour & Clock Tower

A view east, dating from 1968, shows the landmark clock tower that once stood just to the east of Victoria Harbour. In the 1990s this disappeared, along with the rest of the Scott Lithgow shipyard and all of the other buildings in the picture. Today, the Scotts clock tower site is a car parking area adjacent to the Holiday Inn.

Inset: The Scott Lithgow buildings that flanked the main road, shortly before they were demolished.

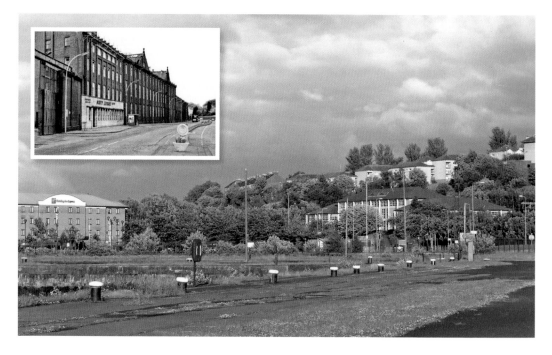

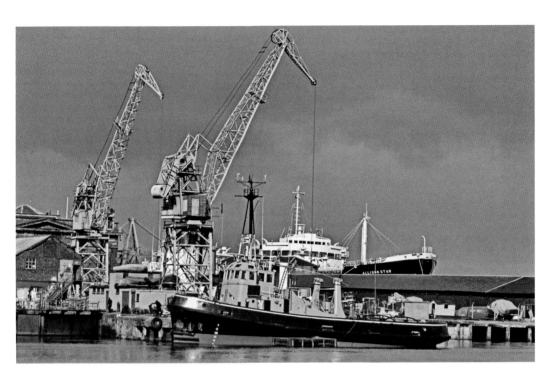

East India Harbour

A 1981 view, looking west towards Dock Breast, shows the James Lamont ship-repair yard, with a ship berthed at Custom House Quay beyond. The Custom House itself is visible at the left of the picture. Lamonts, which had been founded in 1870, was forced to close in 1989 and the site lay derelict, until work began on a new Arts Centre in 2010. A modern view shows the partially completed building, scheduled to open in autumn 2012.

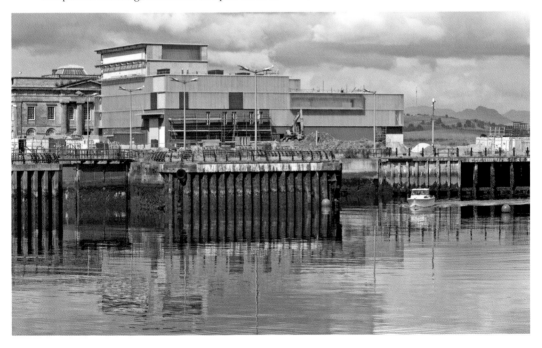

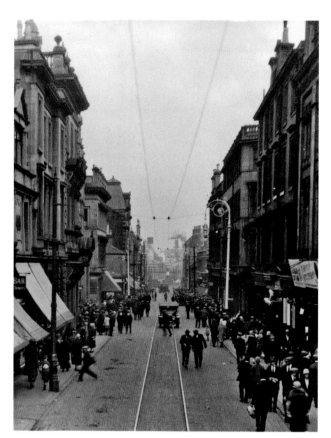

Cathcart Street Looking East

This early view, looking east in the 1920s, may have been taken from the top deck of a tram on the line that continued westwards along Hamilton Street, which no longer exists. At that time buildings existed on both sides of the street but, today, the street is much brighter and more open, as those on the south side have long since been demolished and this area is now a car park. On the north side, the only building in the early picture that still stands is the former General Post Office, which has survived because it is Grade B listed. In 1899, this had replaced the original Tontine Hotel, which previously occupied this site.

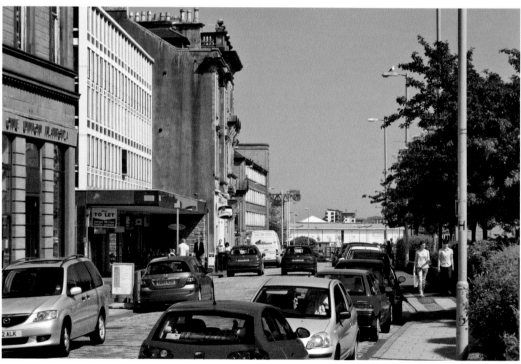

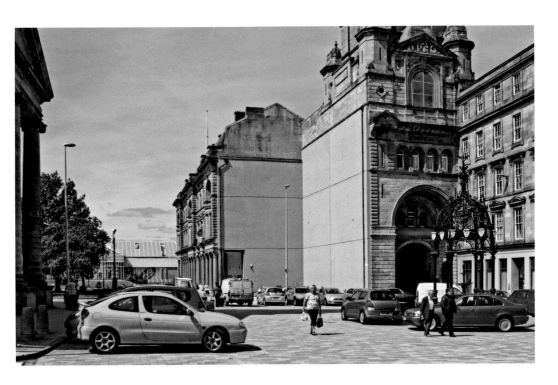

Cathcart Square/Hamilton Street

The modern view looking west has changed considerably from the 1920s version, as much no longer exists. When the Oak Mall was built in the 1990s, Hamilton Street disappeared; 'Cowans Corner' was never rebuilt after being bombed during the Second World War, and the buildings on the left of the early view were demolished in a 1931 re-development, when this area became the gardens of Clyde Square.

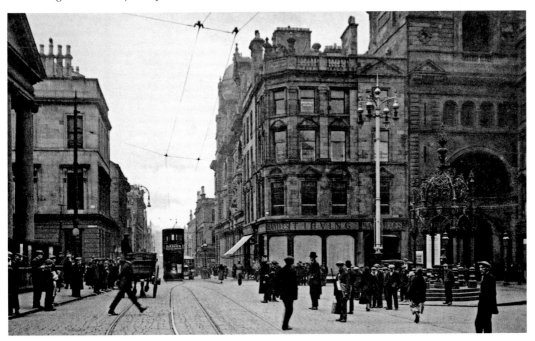

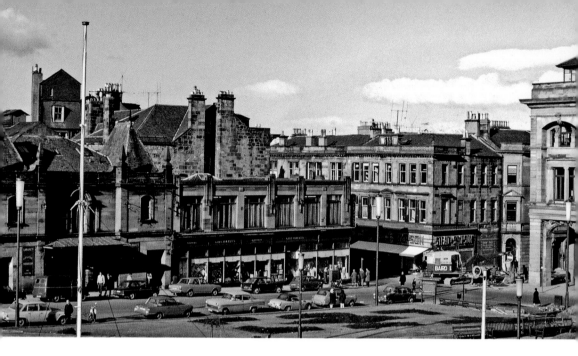

Clyde Square

Of the buildings in this 1968 view, only the Town Hall still exists – a corner of which allows the original viewpoint to be identified. Today, however, this is blocked by the former Central Library building, which occupies the area to the left – forcing any modern viewpoint to the right. No longer accessible to vehicular traffic, this part of the town, adjacent to the eastern entrance to the Oak Mall, has become a quiet pedestrian precinct with trees and flower beds.

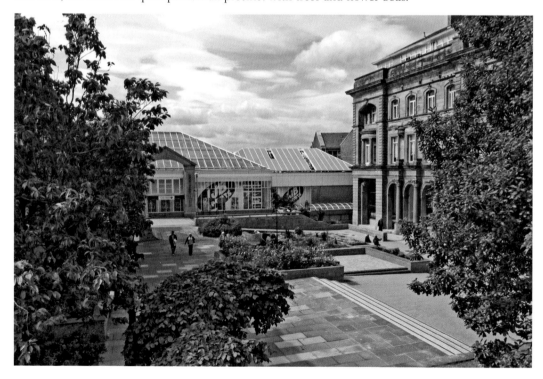

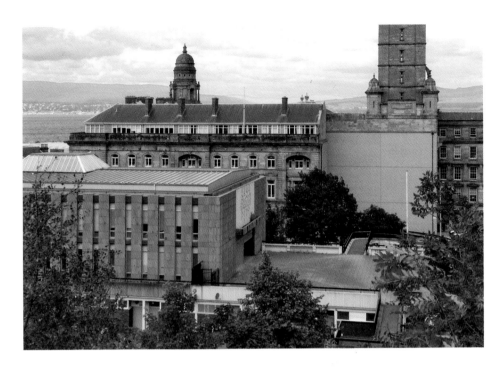

From Shaw Place

One part of the town that has seen massive change is the area in front of the Municipal Buildings. The site occupied today by Clyde Square and the building that, until 2012, was the Central Library was once part of the Vennel, which was cleared for re-development in 1931. The Town Hall itself has also changed, since parts were in an unsafe condition after the Blitz and had to be removed.

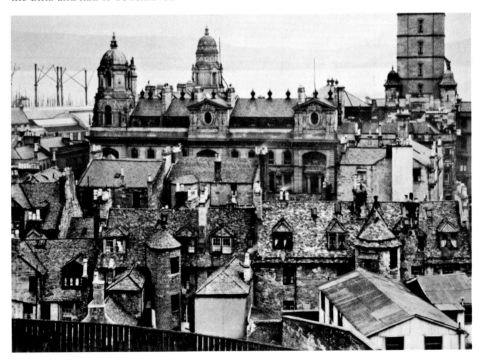

Bank Street

In 1966, the view looking down towards Cathcart Square had a 'closed in' appearance, but this has completely changed today, as the buildings at the bottom of the hill have long been demolished. Where they once stood is now the Cathcart Street car park and the area has taken on a much more open aspect.

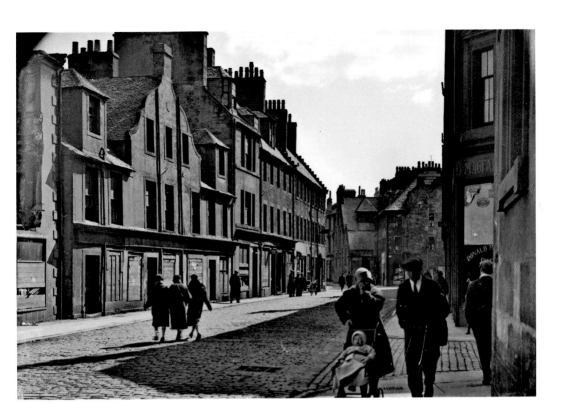

Shaw Street

This early view must date from before 1919, as Shaw Street disappeared during re-development at that time – becoming an extension of Dalrymple Street. In the distance, just beyond the Cross Shore Street junction, is Shaw Street School, which must have stood where the trees now grow on the right of the present-day picture.

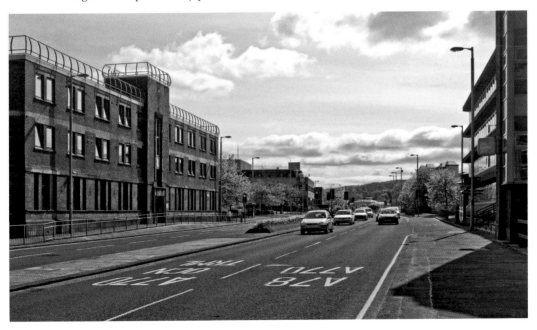

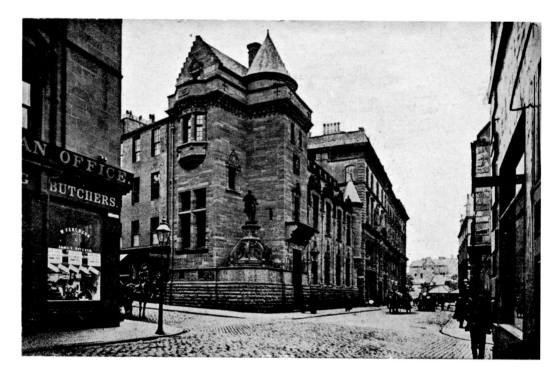

William Street/Dalrymple Street Junction

The building on this corner was the Watt Memorial Engineering and Navigation School, opened on 1 June 1908 by Dr Andrew Carnegie. Built on the site of James Watt's birthplace, it still survives today, though the surrounding area has changed completely. Where the buildings on the right of the early view once stood, there is now a dual carriageway leading to a roundabout, known locally as the 'Bull-ring'.

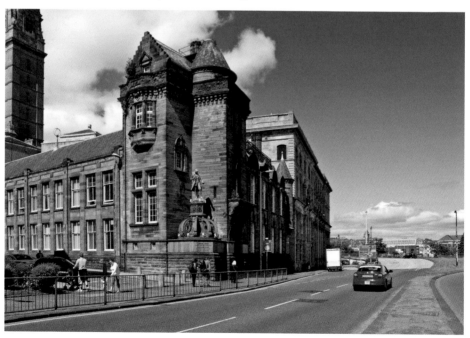

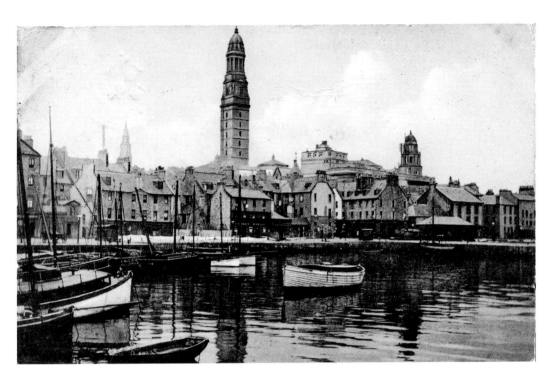

Greenock from the Harbour

The viewpoint for the above picture, dating from before 1915, has been one of the most difficult to track down. It was taken across the West Harbour and shows the East Breast and part of the Mid Quay, which was an extension of William Street. However, the harbour has long since been filled in and boats have given way to cars. Lidl may have no idea that the site of the store was once underwater!

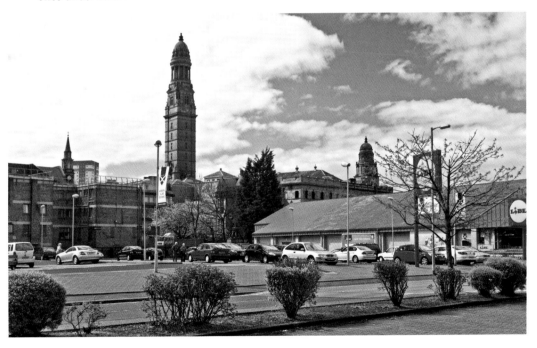

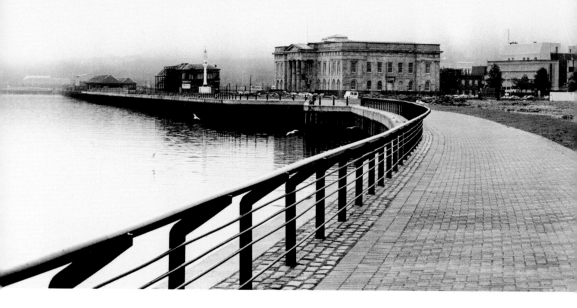

Custom House Quay

Though the older view dates only from the 1980s, this pair of images documents past and continuing change along the waterfront. Once clearly seen, the Customs House is now invisible from the original viewpoint, completely hidden by the James Watt campus. Behind the clock tower is the new Arts Centre under construction and the corner of the Waterfront complex can just be seen on the right of the present-day view.

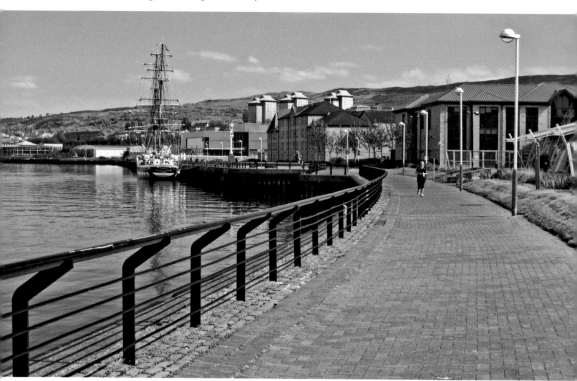

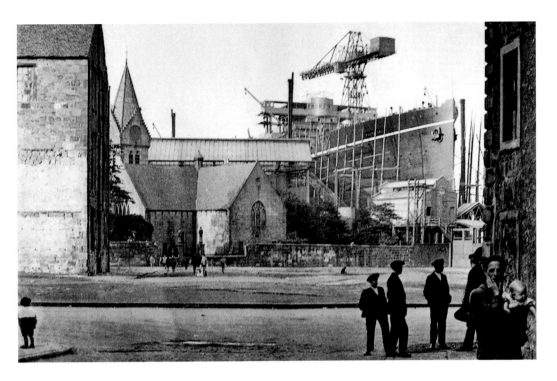

Old West Kirk Relocated

The original 1591 kirk, reputedly Scotland's first post-Reformation Protestant church, was replaced in 1864. However, many people may not realise that it no longer stands where shown in an early view. To prevent it being engulfed by shipyard expansion, in 1925, Harland & Wolff paid for its dismantling, stone by stone, and rebuilding at the Esplanade, from where the 'sailor's kirk' has a clear view of ships passing on the river. The original site, opposite the end of Nicolson Street, is now the Tesco car park.

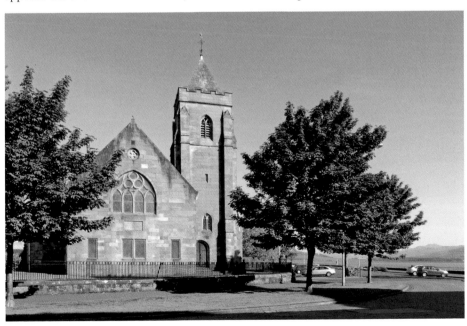

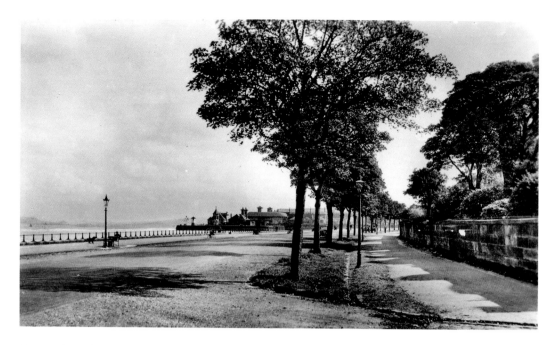

Greenock Esplanade

The west end of Greenock is fronted by the Esplanade. Known locally as 'The Splash', this is a popular recreational spot, as it provides a gently curving riverside walk, about a mile and a quarter in length. An early view looks east from the corner of Fox Street. In the distance, the turrets of Princes Pier Station can be seen – where the railway service once connected with the steamer service on the Clyde, but where container ships and cruise liners now berth.

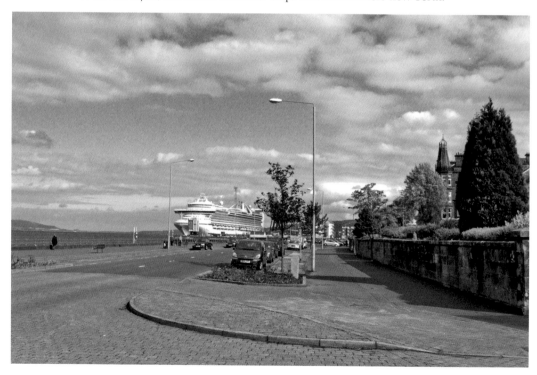

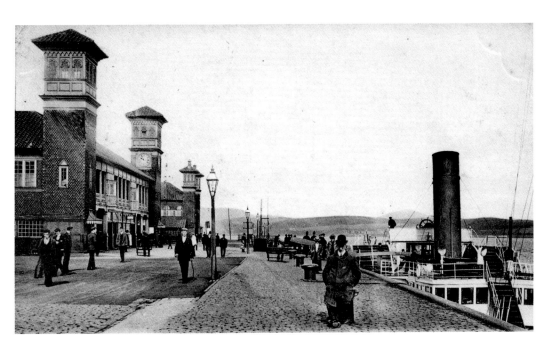

Princes Pier/Greenock Ocean Terminal

An early view shows the attractive Victorian station that Princes Pier once boasted – the connection point with the railway for the Clyde steamers, one of which is shown at the quayside sometime in the early 1900s. This beautiful turreted landmark was demolished in 1967 and no evidence survives. Now within the container terminal, the site is no longer accessible to the public, except to passengers on board cruise ships, such as the *Queen Elizabeth*, which berth there.

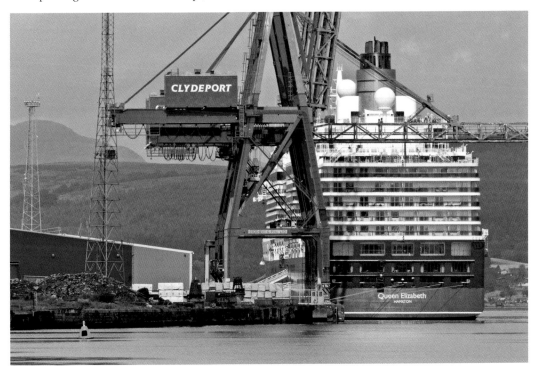

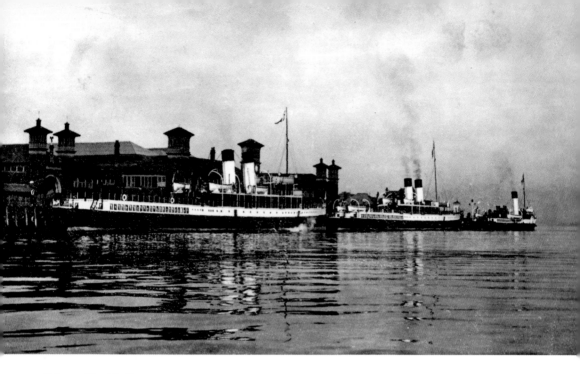

Princes Pier Station

A common regret of the people of Inverclyde is the demise of the station. Originally built for the Greenock & Ayrshire Railway, this was opened on 25 May 1894. It was the terminus for a service that ran from Glasgow St Enoch, via Paisley, Kilmacolm, Port Glasgow and Greenock Lynedoch Street. Passenger services were withdrawn in 1959 and other services ceased six years later. The station closed in 1966. A present-day view shows that the pier itself now serves Greenock Ocean Terminal.

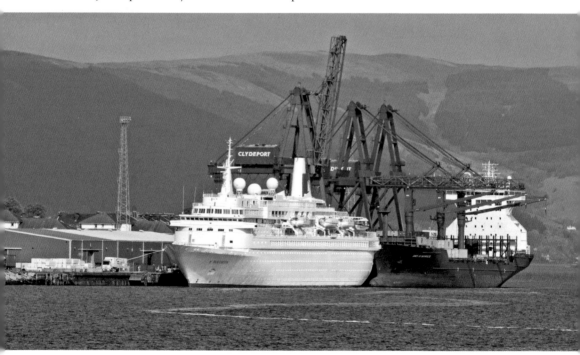

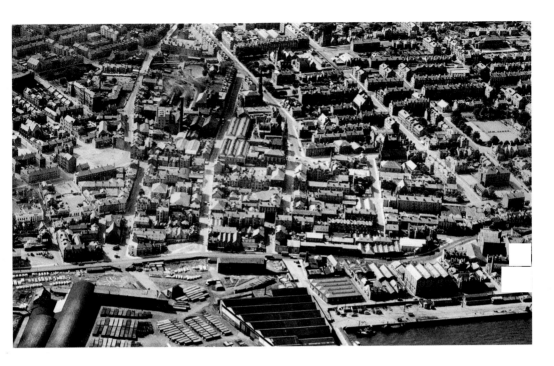

Central Greenock from the Air

Changes in the central area may be compared in aerial views from 1947 and 2011. To note but a few: Nicolson Street is no longer continuous; Hasties has gone, as has Walker's sugar-house and the railway sidings that once served it, and what is now the container terminal was once the wet dock just visible at the bottom right of the early view.

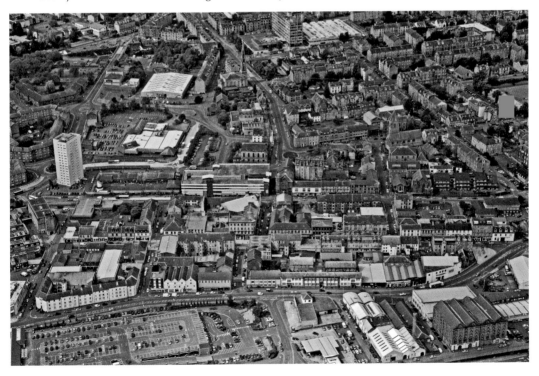

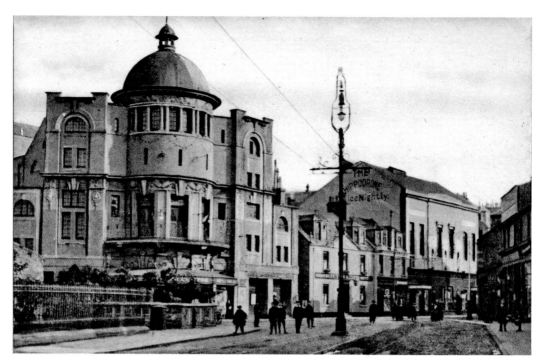

Grey Place/West Blackhall Street

An early view looking east from Grey Place, showing the King's Theatre and Hippodrome, dates to before 1923, when the latter was demolished. The King's became the Odeon Cinema in 1956 and lasted until 1973 – a victim of re-development. Dalrymple Street now runs through here, so the view today is very uninteresting. The change is best represented, therefore, by standing on the old site of the King's looking across the gap, along West Blackhall Street. *Egeria* the wood nymph, a sculpture by Andy Scott, stands today where the Hippodrome once stood.

Inset: The boring present-day view from the original viewpoint.

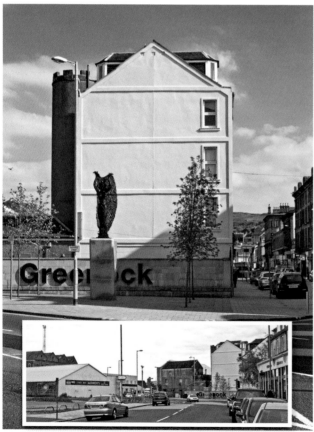

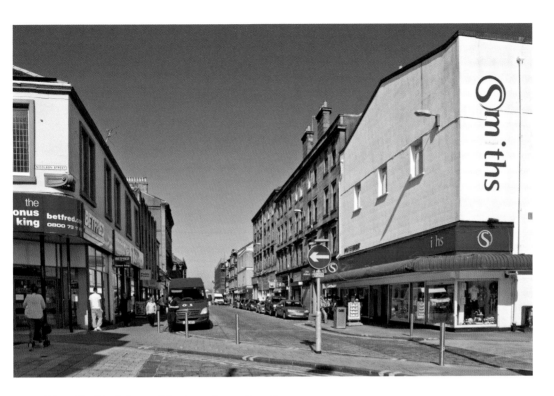

West Blackhall Street/Nicolson Street Junction

Most of the buildings in this part of the town are still here. Though the Smiths building has been modernised and raised, it appears to be the original Hodge's building shown in the early view, probably taken in the 1930s. In the distance, at the western end, the King's Theatre can be seen.

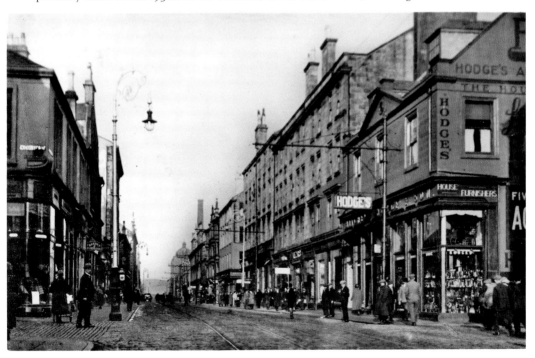

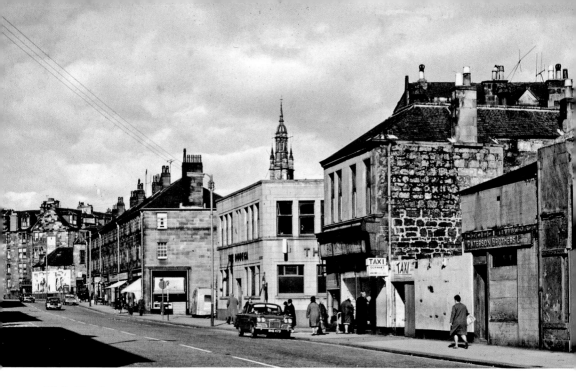

High Street

In 1968, this was a busy commercial thoroughfare. Today, the shops are gone and the street acts mainly as a link road between the Kilblain Street roundabout and the 'Bull-ring' roundabout on Dalrymple Street. The viewpoint is now identifiable only from the church spire in the centre. The area on the right now serves as a delivery and pick-up point at the rear of some of the shops in the Oak Mall.

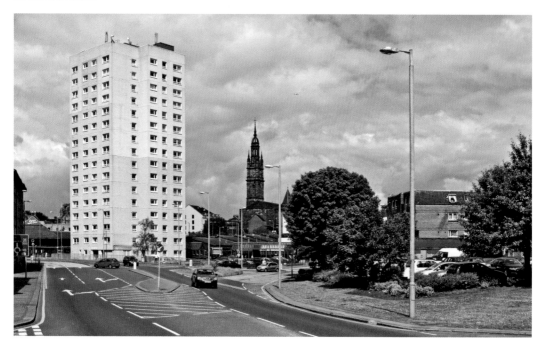

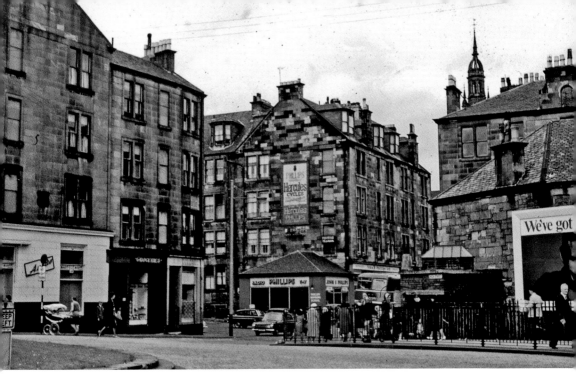

Kilblain Street

In 1968, this connection between Inverkip Street and George Square was heavily built up. Then, only the tip of the spire was visible, but today's aspect is much more open and the church, as well as other buildings along Nelson Street, one of which is the Sheriff Court, can be clearly seen. Kilblain Street has become a bus stance/depot, so the connection to George Square is now closed to ordinary traffic.

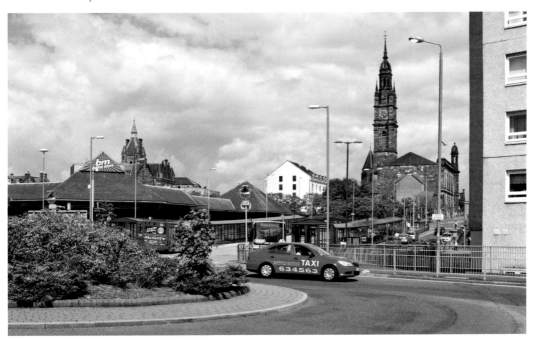

Nicolson Street/Princes Street Junction

This area has changed almost beyond recognition. The early viewpoint can be identified from the buildings on the far left, and just visible at the top is part of the church spire, now completely revealed in the present-day view. Central Nicolson Street is now cut off and has become a bus-stance; Princes Street is hidden from view. Where buildings once stood is now a car park, with Hastie Street created above it. A red car travelling along the new road is just visible on the left.

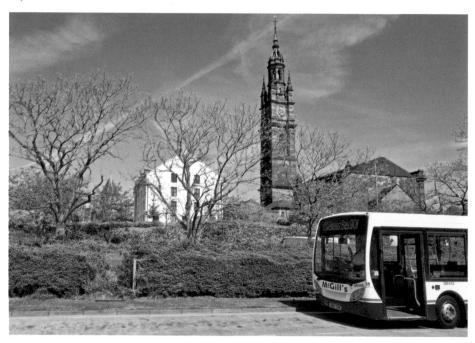

Tobago Street Looking West

A modern view shows the surviving eastern half of the street, which today extends only as far as Sir Michael Street, though it once extended all the way through to Inverkip Street. The section shown in an early view is, in fact, the western half that no longer exists, but the present-day view aligns exactly and has a remarkably similar perspective.

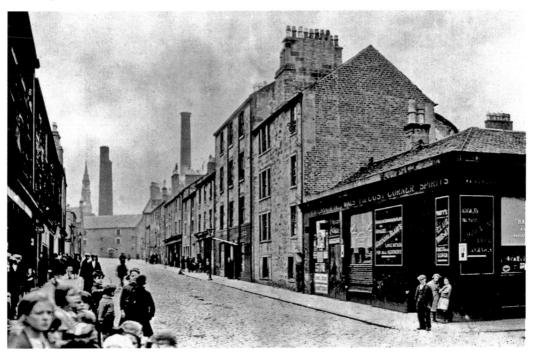

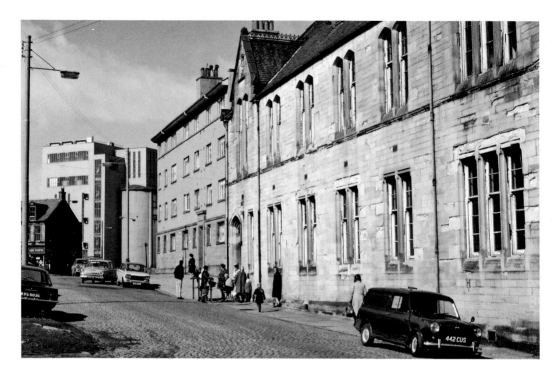

East Shaw Street

A view from 1968 shows the East Shaw Street School on the right and Walker's Sugar Refinery on the left, both of which are now gone. The sugar-house, on the other side of Inverkip Street, closed in 1979 and the site is now occupied by the Homebase store. The tall building visible in the distance is the James Watt College.

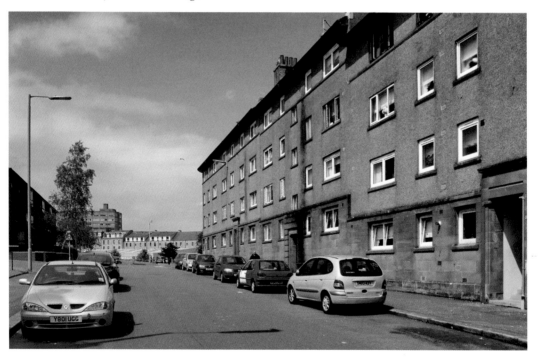

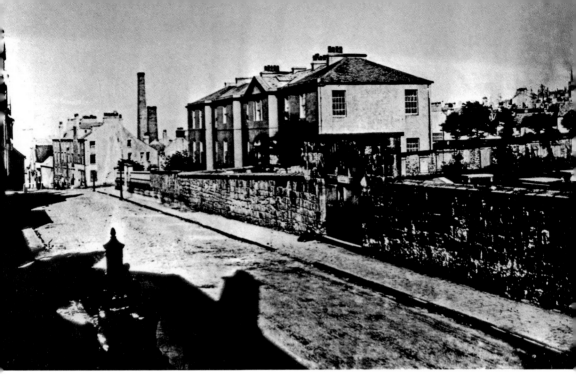

Inverkip Street

An early view, though poor-quality, shows the old graveyard on the right, dating from 1786, and beyond is Greenock Infirmary, which opened in 1868. Permission to use the title 'Royal' was granted by King George V in 1922. The hospital closed in 1979, when Inverclyde Royal Hospital was opened, and was demolished in 1983. John Galt House, a sheltered housing complex, now occupies the site.

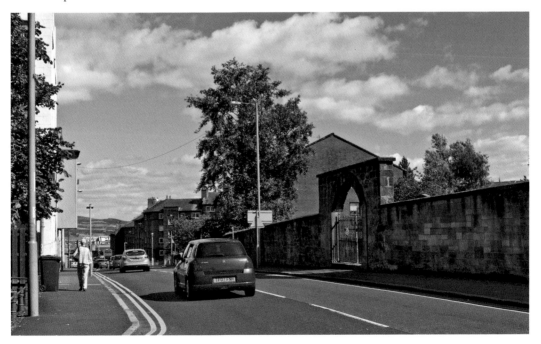

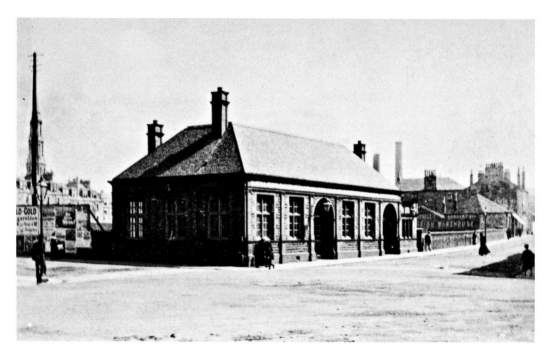

Greenock West Station

In 1882, the Caledonian Railway was granted permission to build a station, fronted on Inverkip Street by 'a very neat and substantial stone building in Renaissance style' with two 'large and handsome' doorways. Today, the building still stands, though the chimneys have been removed, its original arched doorways have been converted into windows and its central window openings have become new, narrower doors.

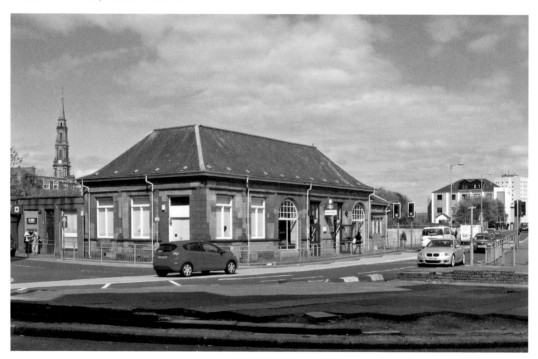

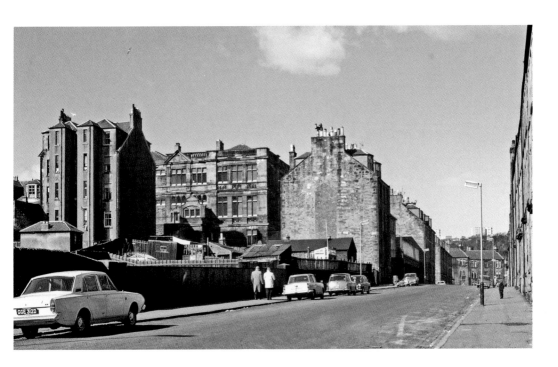

Wellington Street

A 1968 view shows Highlanders Academy flanked by tenement blocks, both of which have now disappeared, having been replaced by a gym-hall extension to the school and a small park area. Highlanders was built on the corner of Mount Pleasant Street and Wellington Street in 1887, after the original school had been demolished to make way for Greenock West Station. It closed its doors to pupils finally in June 2012 when it amalgamated with Overton to form Whinhill Primary where, as in the Highlanders Academy of old, gaelic is still taught.

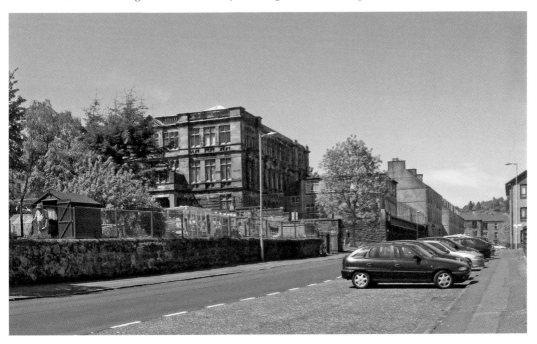

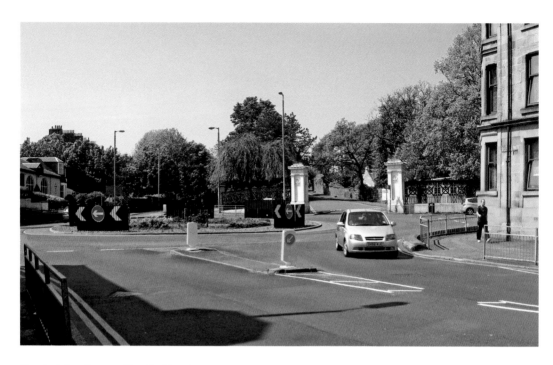

Brachelston Square/South Street

The modern viewpoint looking towards Greenock Cemetery gates at the bottom of South Street is one that is easy to trace from an early view, but the changes are considerable. Attempting to stroll around here, as the people were doing about a century ago, could prove fatal today! The name Brachelston Square seems to have fallen into disuse and now this is usually just referred to as the South Street roundabout.

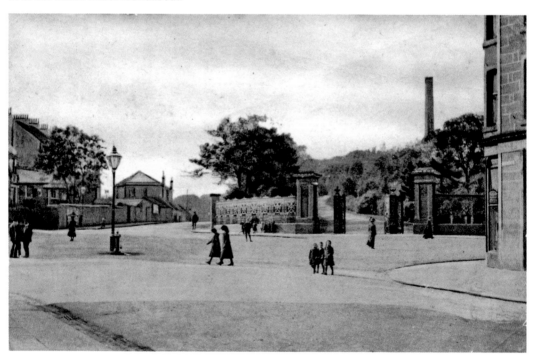

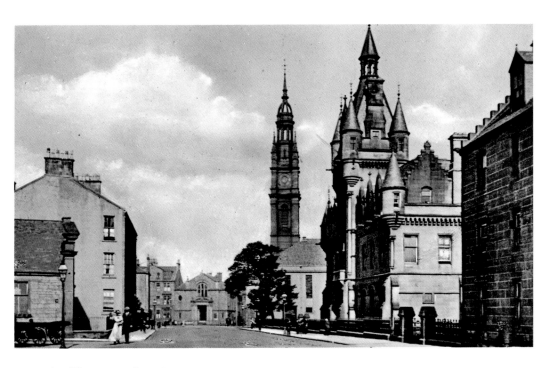

Sheriff Court, Nelson Street

With only one obvious exception, the buildings that were adjacent to the court in the above view, dating from about 1925, are still there today. Only the bottom-left building, at the corner of Nelson Street and Ardgowan Street, no longer exists, having been replaced by the ACCESS wing of Ardgowan Hospice.

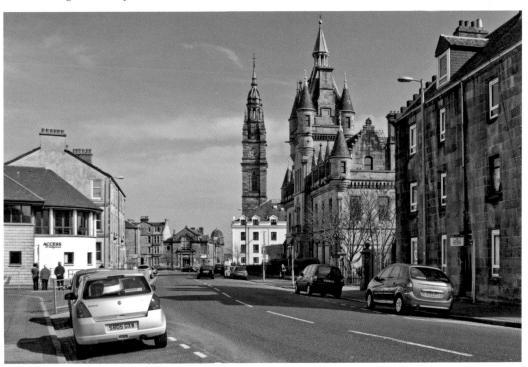

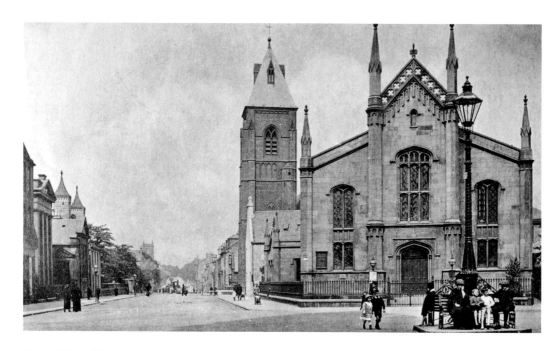

Union Street from George Square

On the right of this early view stands the Congregational church, which was built in 1839. This Grade B listed building is now known as Greenock West United Reformed Church, the congregation having been united with that of Nelson Street URC. Of the three churches that face onto George Square, only this one remains in use as a place of worship.

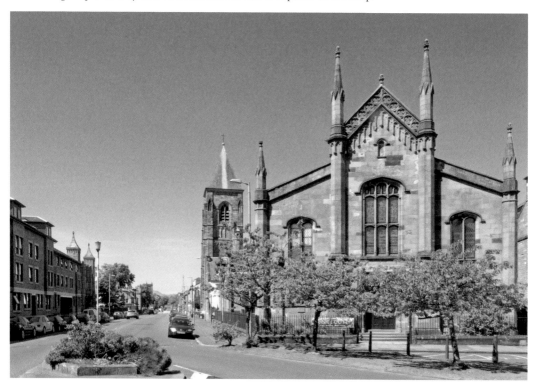

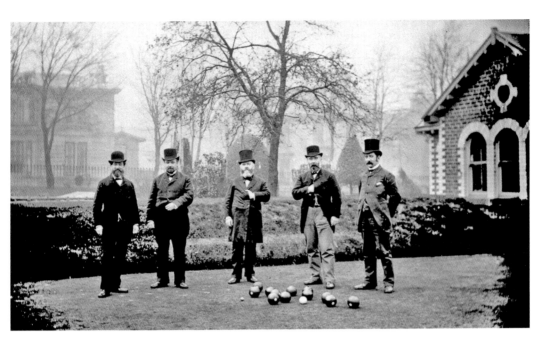

Ardgowan Club

The worthy gentlemen in this picture, dating from around 1900, were members of what was the first club to be founded in Inverclyde. In 1841, the area now known as Ardgowan Square was laid out for the playing of bowling, curling and quoiting. The first clubhouse, visible in the early view, was built in 1860; the modern clubhouse dates from 1926. It may be seen that the dress code for Ardgowan bowlers has been relaxed considerably over the years!

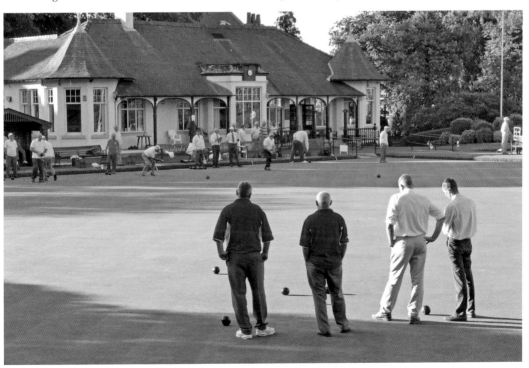

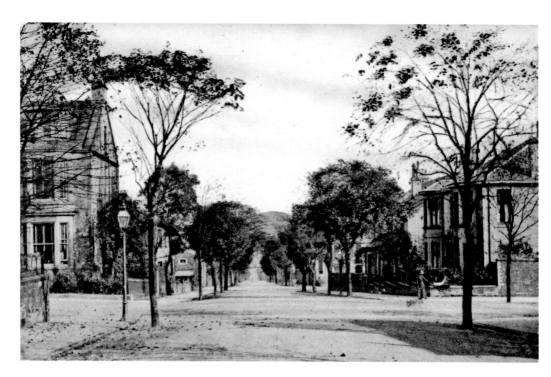

The West End

This region of Greenock has always primarily been residential and has seen little change over the years. An early-twentieth-century view looking north, towards the Firth of Clyde, along Forsyth Street at its junction with Finnart Street, looks little different now than it did then, but for today's more luxuriant vegetation – clothed in bright spring green.

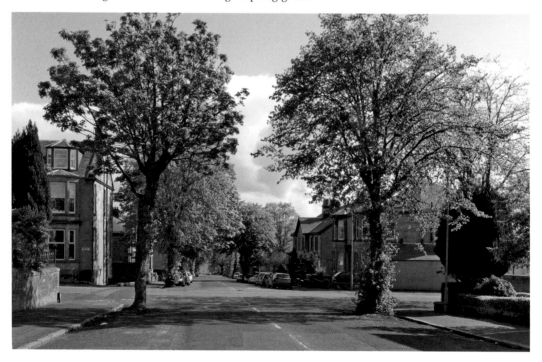

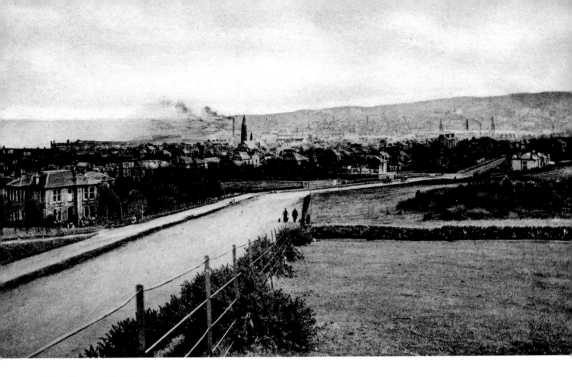

View from Lyle Road

These views illustrate the expansion of Greenock towards the Lyle Hill. The original viewpoint is inaccessible because of the heavy growth on the right of the present-day view, which is from the other side of the road, though from about the same height. The original iron fence actually still survives – though buried in the undergrowth! The people in the early view, from about 1910, appear to have been walking roughly where the cars are parked.

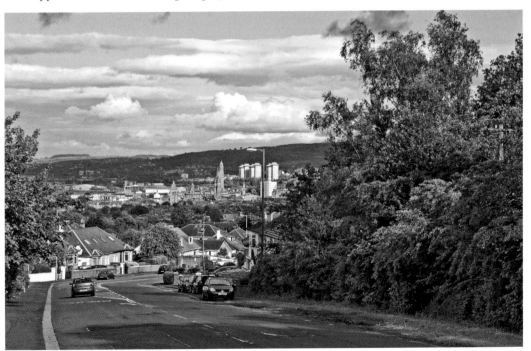

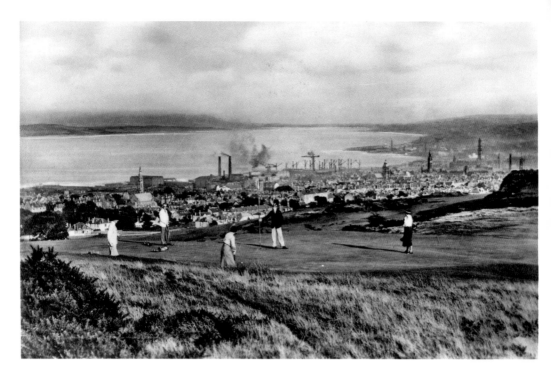

Greenock from the Golf Course

Greenock golf course affords stunning views across the town and eastwards up the Clyde. An early view shows shipyards and sugar-house chimneys, both now long absent from the scene. Today, the course has matured considerably, so much of the town is now obscured by trees, but on a clear day, the Erskine Bridge, some 13 miles distant, may be seen.

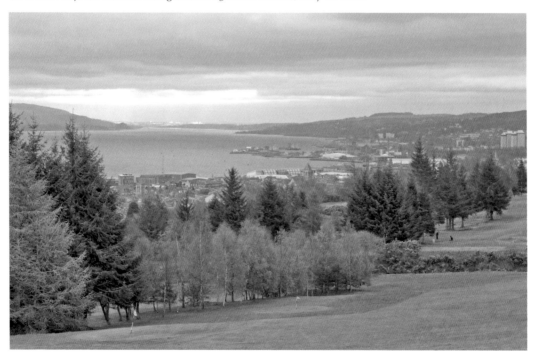

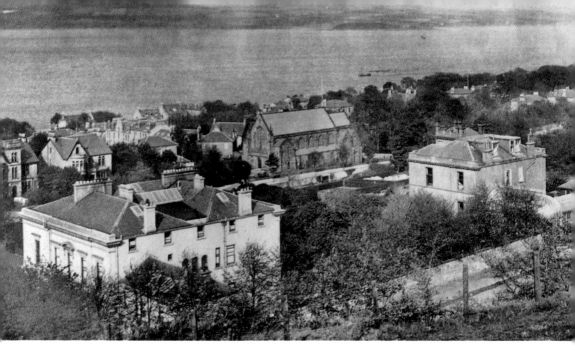

From Lyle Park

The west end may seem timeless and largely unaltered, but there have been changes. The mansion houses in an early view have, today, given way to housing developments. However, the church in the centre of both views, the former Finnart St Paul's, has remained constant. Falling church rolls have led to amalgamation with Ardgowan and the Old West to form the new Lyle Kirk congregation, so the future of this beautiful red sandstone church is uncertain.

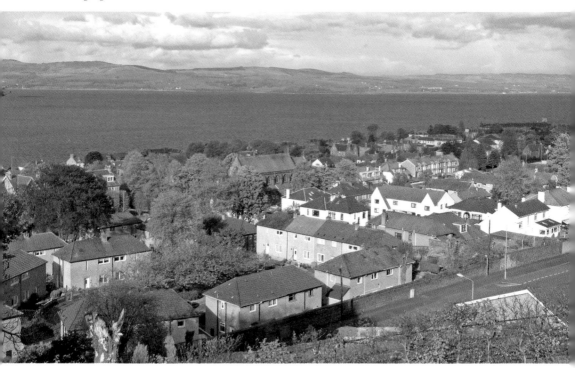

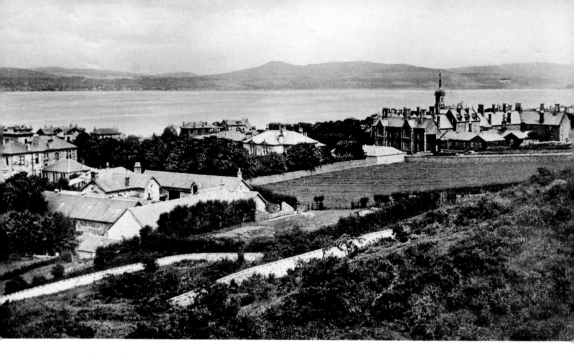

Gabriel Woods Mariners' Home

An early view showing the Home along with Drums farm is impossible today, as no suitable gap exists in the vegetation. Both buildings are still there, but have to be pictured separately and from slightly different angles. The care home for master mariners and merchant seamen was built in 1850 and is still in use; the farm buildings (*inset*) are now private houses and the fields are the residential areas of Drums Terrace and Lylefoot Crescent.

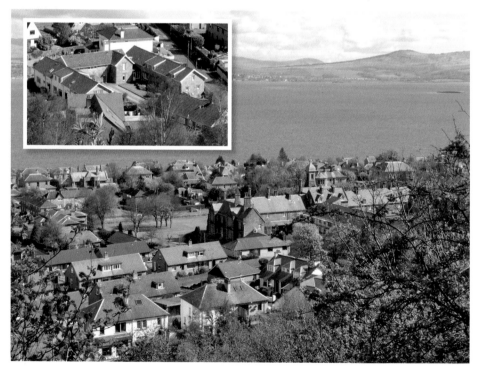

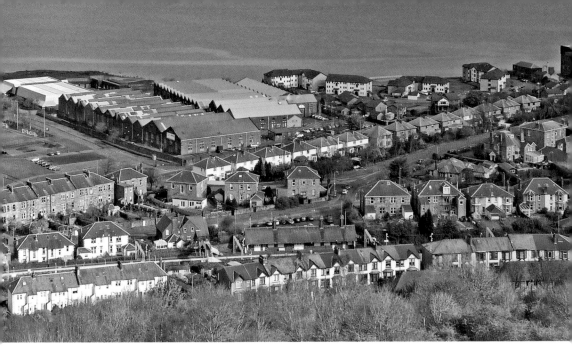

Clyde Torpedo Factory

Vegetation on the lower slopes of Lyle Hill makes it impossible to re-create the early view of the Torpedo Factory, so a present-day view had to be taken from the top of the hill. The factory was built in 1910, on ground levelled using material excavated for the Fort Matilda railway tunnel. The station and many other adjacent buildings remain and may readily be identified. The factory closed in 1969, but since the buildings are listed by Historic Scotland they survive and now house various local businesses.

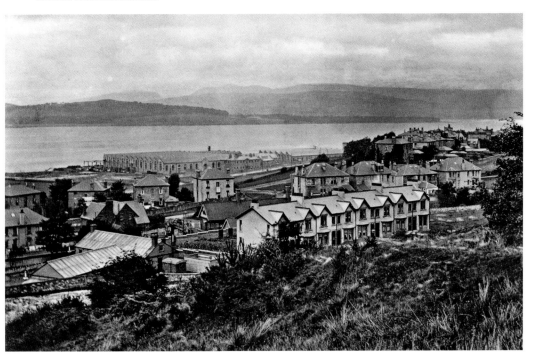

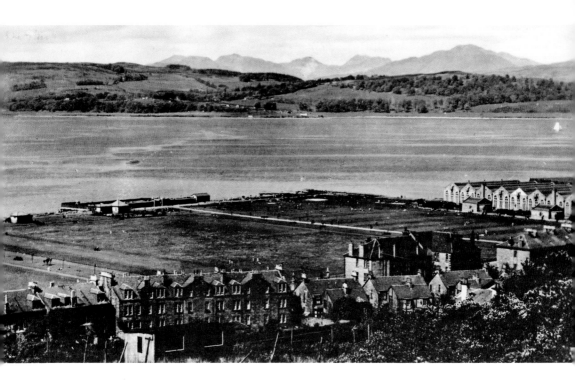

Battery Park

This view probably dates from the late 1930s and shows the outdoor sea-water pool, which replaced an earlier floating bath destroyed by a storm. The pool closed when the Hector McNeil baths opened during the 1960s. For many years there was nothing on the site; however, a pavilion with gym facilities and a café, an all-weather pitch and a skateboard park have now been built. The white building on the seaward side of the old torpedo factory is a water treatment plant.

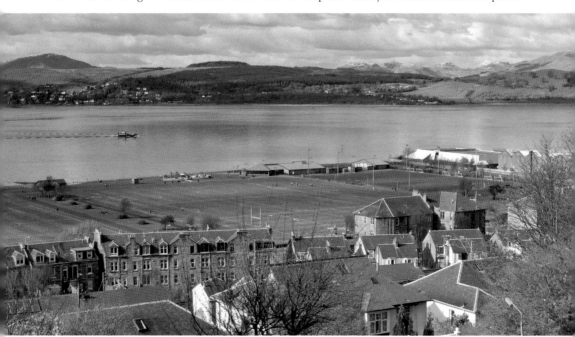

SECTION 2

Gourock

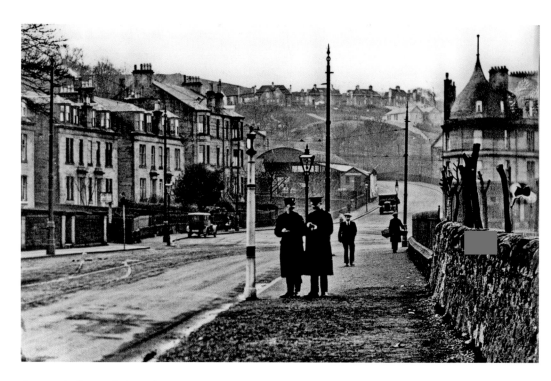

Greenock–Gourock Boundary

A 1920s westward view shows tram inspectors waiting at the boundary between the towns, at the western end of the Battery Park. Today, the marker post is gone, but a lighter-coloured kerbstone appears to mark the approximate position. Buildings on Eldon Street appear largely unchanged but beyond the junction, where Manor Crescent diverges to the left up the hill, new development has taken place.

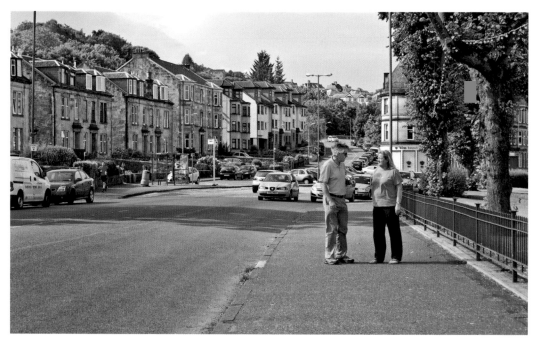

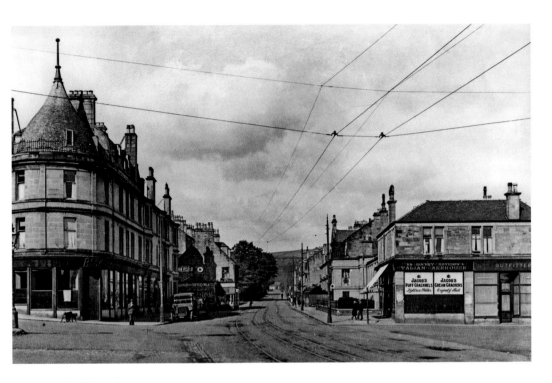

Cardwell Road

An early view shows the start of a row of poor houses jutting out beyond the shops on the left, opposite where the Cardwell Bar stands today. In 1880, these houses were called the 'Irish Row' and later became known as 'Wee Dublin', but now no trace remains. Today, the original viewpoint is obstructed by a car park, so a wide-angle lens has been used to achieve a similar modern perspective.

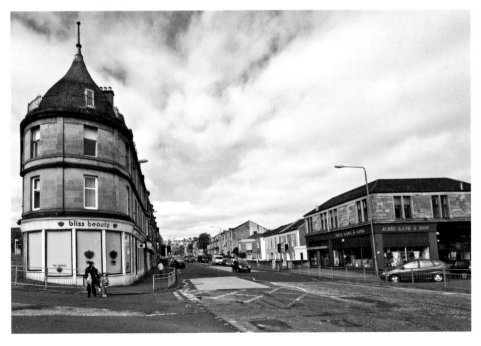

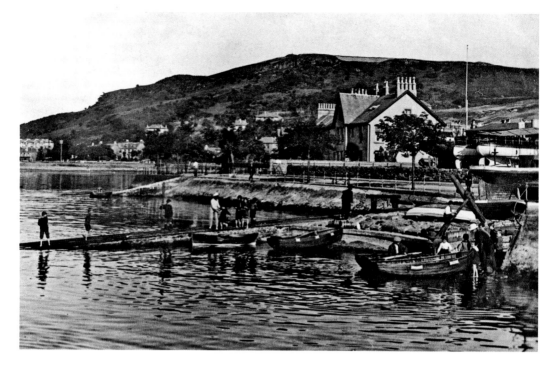

Cove Road

An early (slightly damaged) view, believed to date from around 1923, shows boating activity in Cardwell Bay. Above the house at the top right, which is still there, the retaining wall for the viewpoint on Lyle Hill stands out and appears to have been recently built. Today, sailors still launch their boats from the same slipway, though outboard motors now usually replace oars.

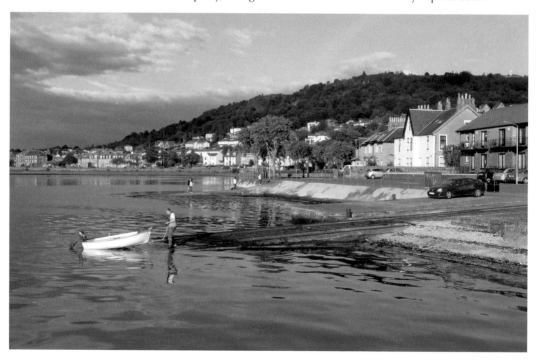

Cardwell Road

An early view of the block stretching eastwards from the junction with Tarbet Street is labelled Allan Place. Today, this name seems to have fallen into disuse, but the red sandstone row remains largely unchanged and is still easily recognised.

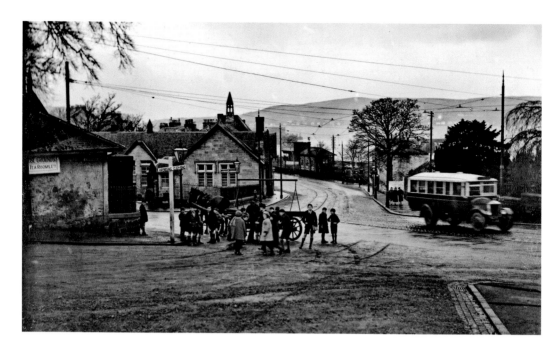

Larkfield Junction

It appears that the only surviving building in this early view is the Albert Bar. On the left is the Eastern School, which was demolished in 1968 for housing re-development, the site now being occupied by the Eastern View high-rise. At the bottom of the Larkfield hill is now located the infamous 'channelised junction', which confuses drivers not familiar with the area. Only the planners can explain why this isn't a roundabout!

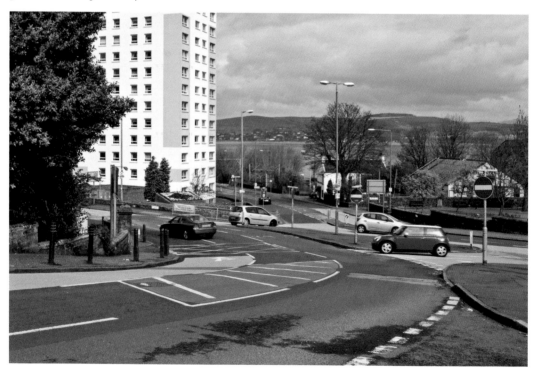

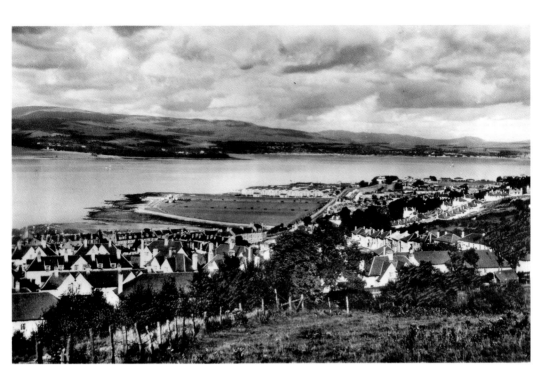

Tail of the Bank

A view across Gourock from behind Reservoir Road looks towards this part of the river, which gets its name from a sandbar extending to the east. This natural anchorage, where the Firth of Clyde becomes the River Clyde, was once heavily used, but few vessels anchor today. Since the original viewpoint is now screened by trees, the present-day view is from a slightly different angle, from where much of the housing is hidden, giving the erroneous impression that the area is less built up!

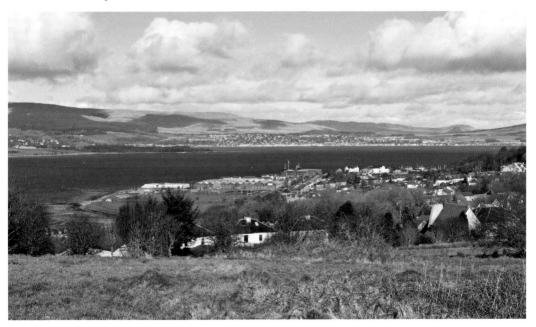

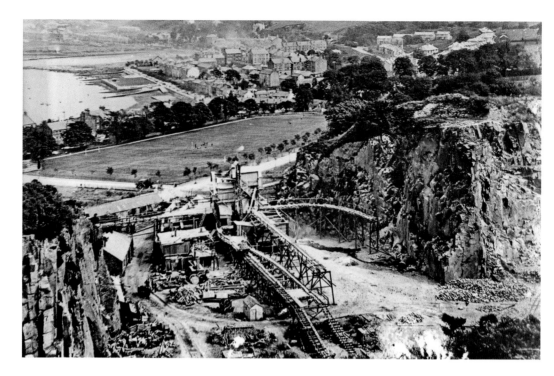

Craigmuschat Quarry

Quarrying began here in the mid-nineteenth century, and a huge amount of whinstone was excavated up until around 1920, from when an early view of the workings possibly dates. A huge, horse-shoe shaped gash was left in the side of Tower Hill (geologically a Trachyte sill), which was controversially used as a landfill site in the 1990s. A slightly wider modern view shows the earth capping on the site and, in the background, the development that has taken place along Shore Street.

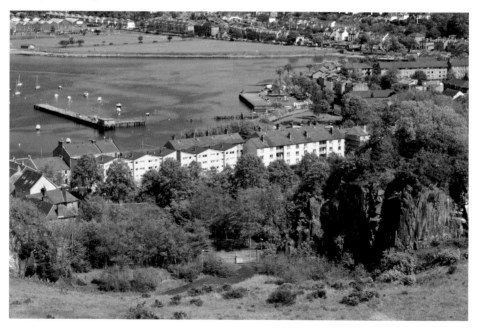

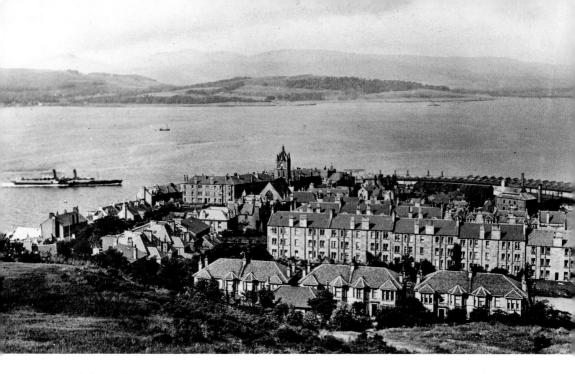

Gourock from Tower Hill

At one time, there were uninterrupted views towards Gourock pier head from Tower Hill. Today, much is obscured by the trees and shrubbery that cloak the lower slopes. Only prior to the spring-time leafing of the trees can the terraced row of houses, so obvious in the early picture, be discerned – just! The lower line of dwelling-houses is now completely invisible. Otherwise, little has changed, except for the railway station.

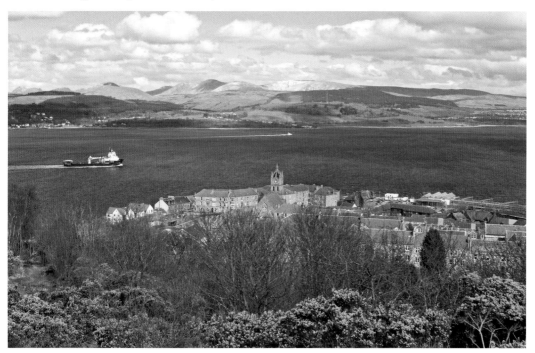

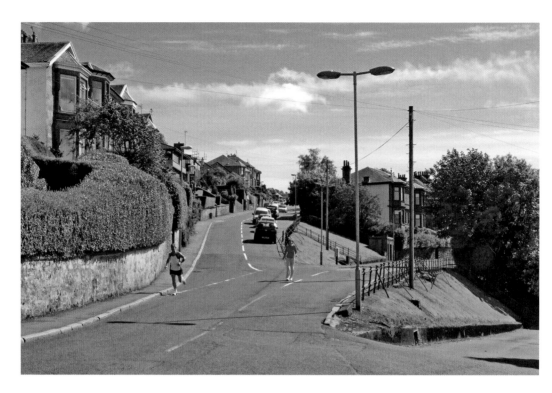

Tower Drive/Victoria Road

Today, the area around this junction appears to be very similar to what it was around a century ago. The same dwelling-houses remain and changes are mainly cosmetic – wider roads, modern lamp standards and the inevitable growth of plants – and of course the presence of the ubiquitous motor car is unavoidable.

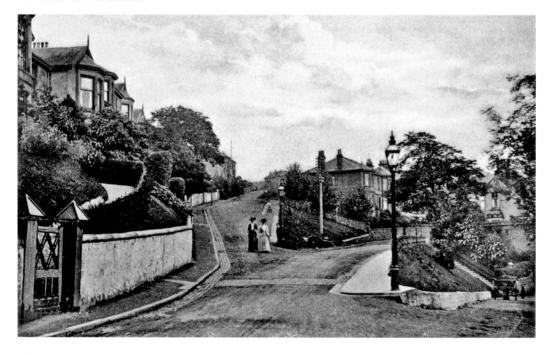

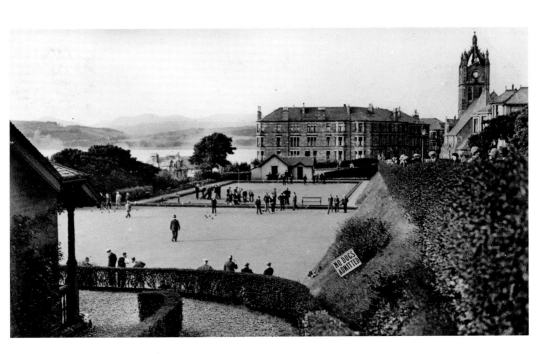

Gourock Bowling Club

Since 1930, from when an early view dates, the clubhouse appears to have been rebuilt and buildings at the far end removed to make way for a third green. Castle Mansions and St John's Church, however, remain largely unchanged. The church was opened in 1857 and the bowling club was founded just under ten years later, in 1866. Despite the absence of a modern sign, dogs are probably still not welcome!

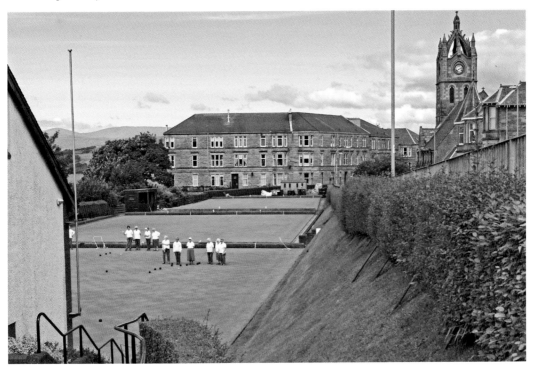

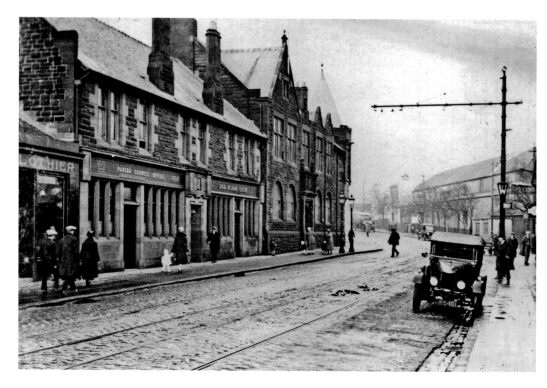

Shore Street

A modern view of the buildings on this block near Gourock Pierhead shows little has altered, though the building on the far left of the early view is gone. However, considerable change has taken place on the other side of the road, nearer to the Pierhead. All the buildings that once stood there have now gone – both those in the early view and those that later replaced them – the Bay Hotel and the post office.

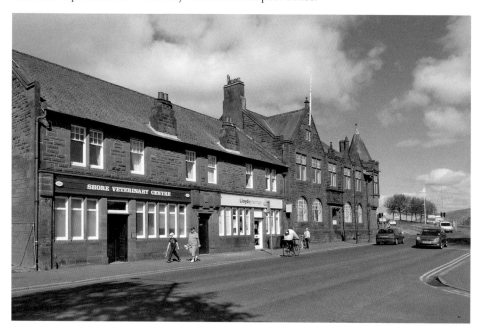

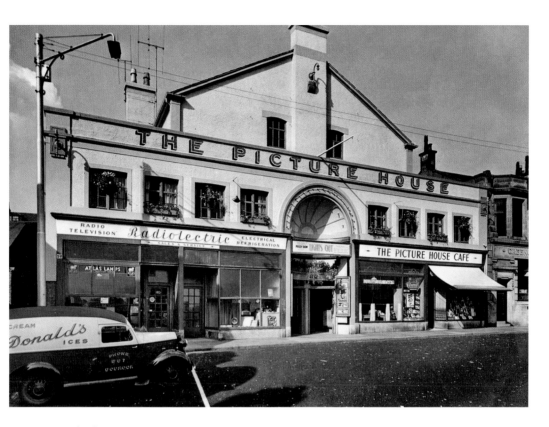

Gourock Picture House

An early view of Kempock Place, probably dating from the 1950s, shows the cinema that was built there in 1913. This was demolished in 1972 and the site is now occupied by the Gourock Library.

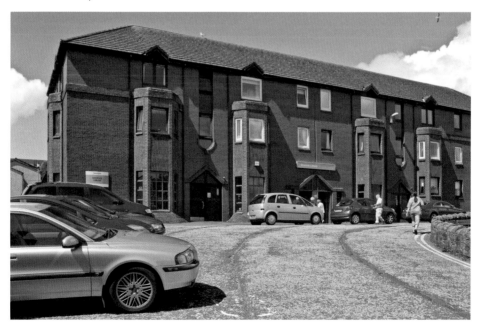

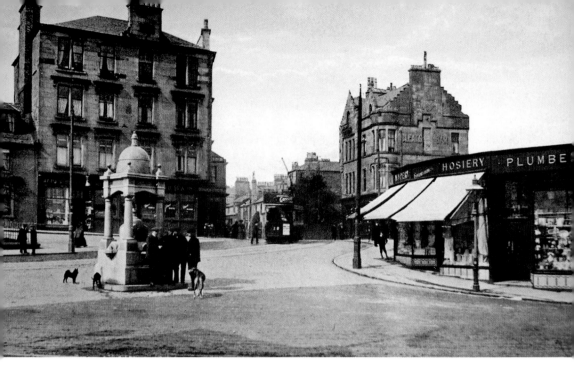

Shore Street/Kempock Street Junction

Taken from Station Road, an early view, probably dating from the 1920s, shows the McPherson Fountain at the Pierhead. During the Second World War, this was removed because it was a hazard to vehicles. It was then 'lost' for many years, rediscovered in a council depot, saved from destruction and rebuilt in 2006 in Kempock Gardens, the corner of which is just visible at the left of today's view. Cleats Bar still exists, though the sign on the second floor is no longer there.

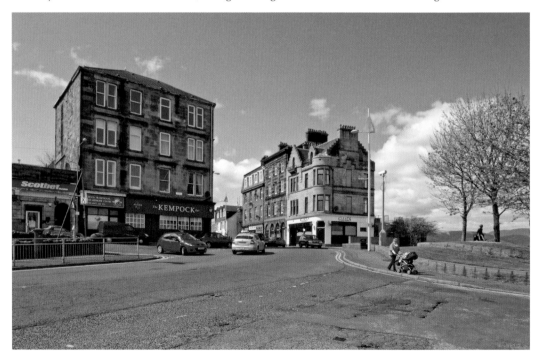

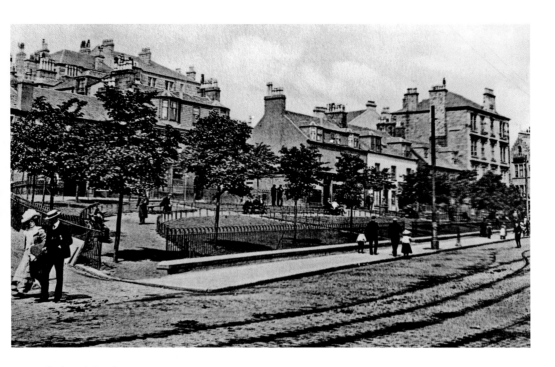

Pierhead Gardens

Opposite the Pierhead, a small garden area separates Kempock Place from the main road. An early-twentieth-century view shows that this has existed for at least a century. Behind the flower beds is the McPherson Fountain (*inset*), which dates back to at least 1902 and bears the name of Captain Duncan McPherson of the GEM Shipping Line, who gifted a cottage hospital to the town. Though this closed in the 1970s, it became the McPherson Centre for adults with learning difficulties.

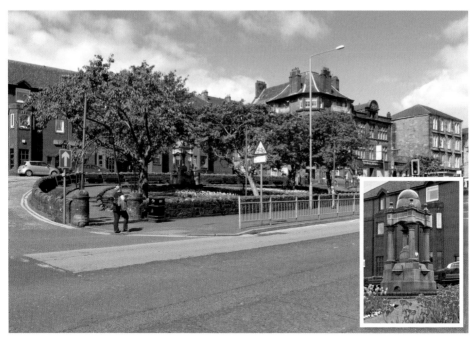

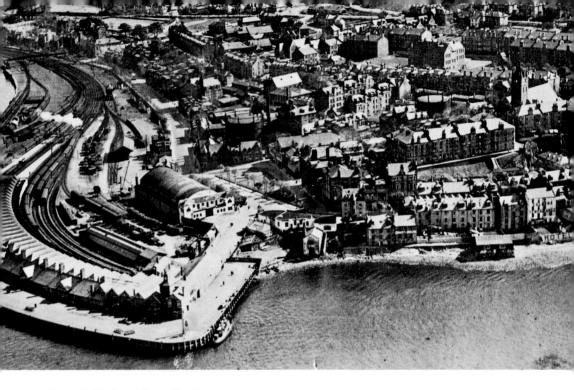

Gourock Pierhead from the Air

An aerial view dating from 1920 shows the railway station and pier. At the junction of Station Road and Shore Street stood the Kursaal, on the site later to be occupied by the Bay Hotel, now also gone. A modern view, though not quite from the same angle, shows the changes – in particular, how far back the station has been moved.

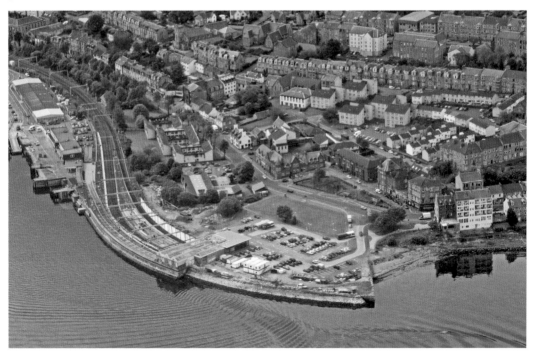

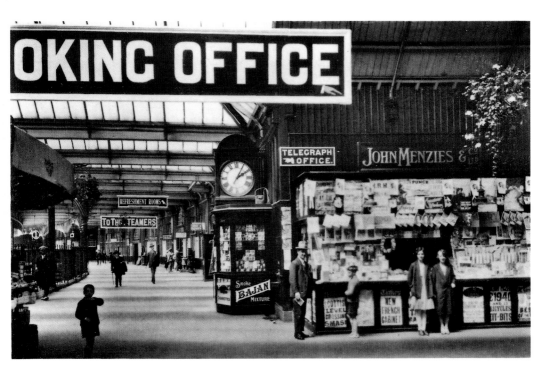

Gourock Station

Nothing remains of the former station, once a thriving stepping-off point for Clyde steamer passengers. Today, it is a very different place, with the shops and dark wood of the old station long gone. Recent modernisation has produced a bright, glass-sided concourse providing lovely views over Gourock harbour. A modern viewpoint has been chosen so that the characteristic elegant curve of the platforms is clear in both views.

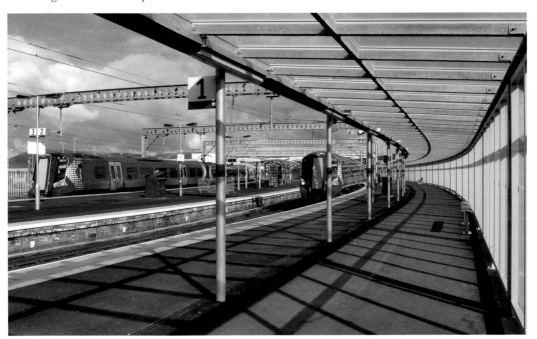

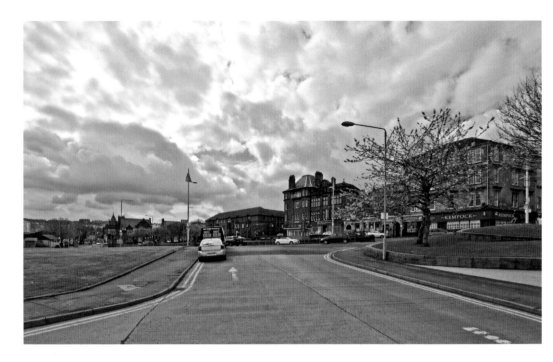

Gourock Pierhead

Today, the area around Gourock railway station is an open expanse, occupied largely by grassed areas and car parking. Once, however, the station access road was flanked by the Bay Hotel on one side and a row of shops on the other. The early view dates from just after 1938 when the hotel was opened. It was demolished in the 1990s.

Inset: The Bay and the former post office, seen from Shore Street in the 1970s.

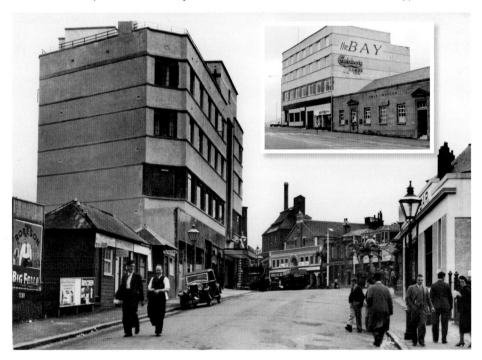

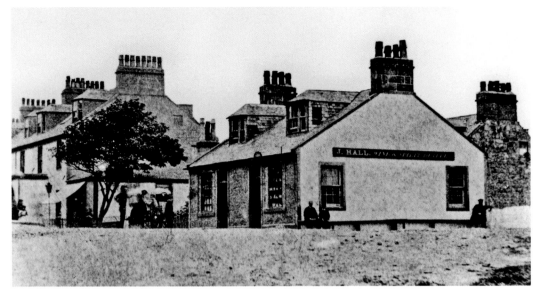

Kempock Street/Pierhead

A late-nineteenth-century view, pre-1890, shows a wine and spirits shop that existed prior to the building of Cleats – the familiar bar that stands on the site today. The characters sitting around back then have today been replaced by a little girl going on holiday! The statue *Girl on a Suitcase* by Angela Hunter has recently been positioned – gazing towards the Pierhead, waiting for a steamer, symbolising the heyday of the Clyde steamers, when people thronged the piers, 'goin' doon the watter'.

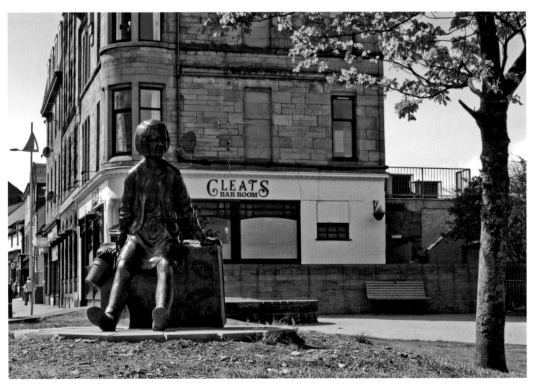

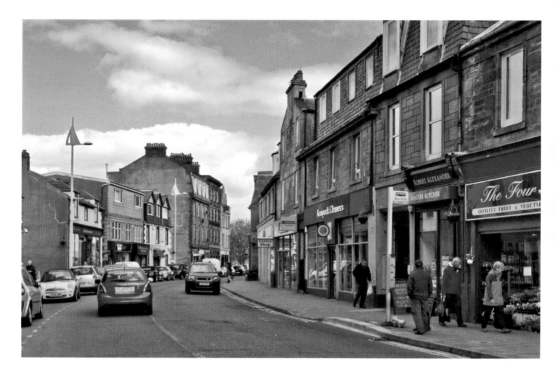

Kempock Street Looking East

Though many of the properties along the section nearest to the Pierhead have changed, particularly on the north side, it is still easily recognisable. On the south side the buildings seem original, but modified. The gable end at the extreme left of the present-day view marks a gap where Veitch's Temperance Hotel once stood – visible in the early view. Today, walking on the roadway is not to be recommended!

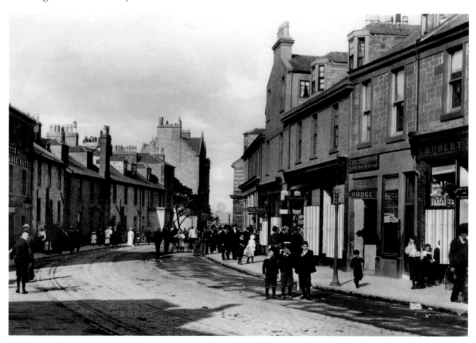

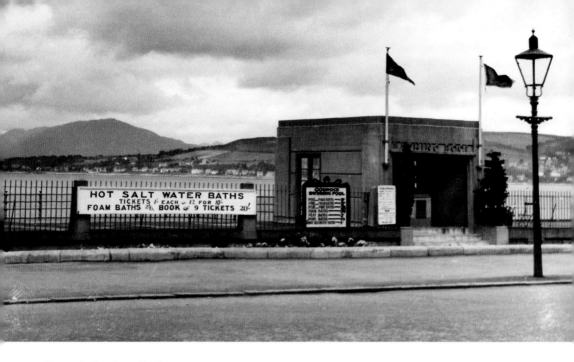

Gourock Outdoor Pool

The salt-water lido was opened in 1909, but a water heating system wasn't installed until 1969, so the early view must date from just after then. At the end of the 2010 season, the pool was closed for major refurbishment at a cost of £1.8 million. The façade was rebuilt in the original style and the pool, the older of the only two heated outdoor pools in Scotland, was re-opened in 2012.

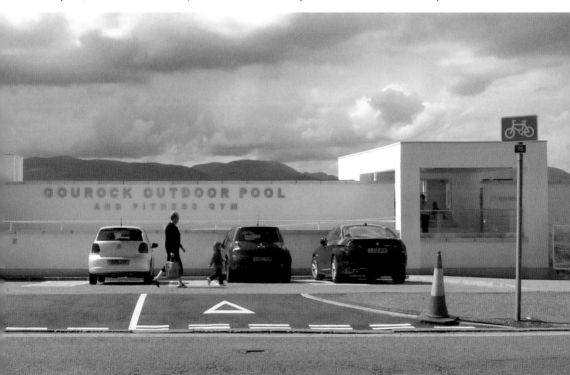

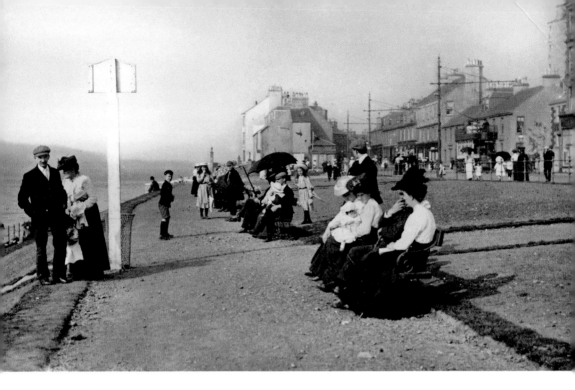

Kempock Front

An early view looking east must date to the early 1900s, as neither the war memorial, which was built in the early 1920s, nor the pool frontage exists, though the salt-water lido opened in 1909 may be just off to the left. However, the building on the far right survives and enables correct alignment of the present-day view.

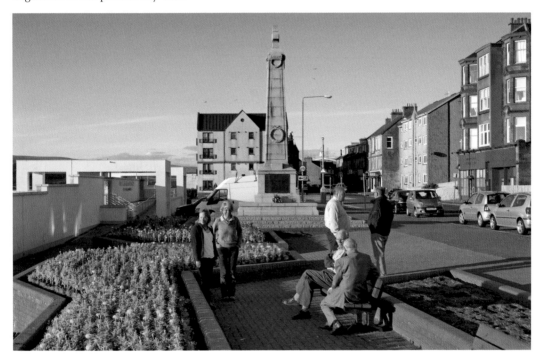

Cragburn Pavilion

Probably today's younger generation is not aware that this modern flat complex occupies the site of the famous Cragburn Pavilion. Originally built in the 1930s as a theatre, this later became a cinema and subsequently a dance hall, where many local marriages were forged. By the 1990s, it had fallen into decline, so the local authority decided that it was of greater financial benefit to sell the land for re-development.

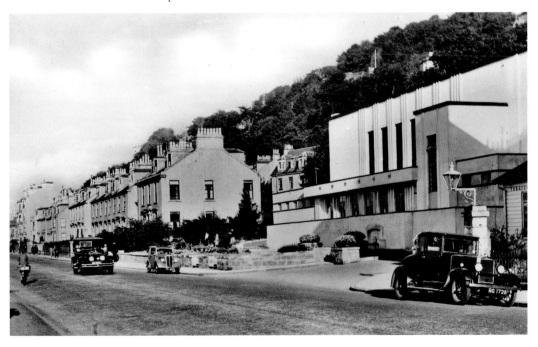

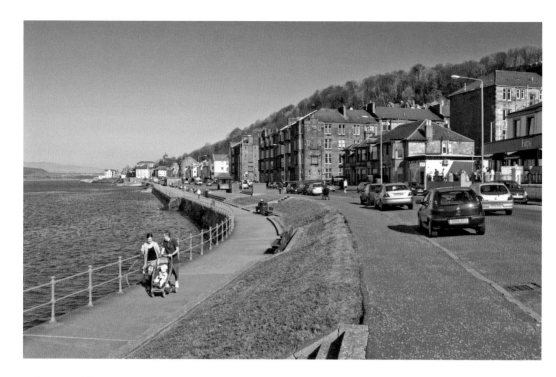

Ashton Looking East

The modern view along Gourock waterfront and promenade looks very similar today to how it looked in the early view, which probably dates to around 1950. Most of the buildings still exist and even the steps and seats appear to be in the same positions, though the handrails have disappeared. The pictures do, however, compare and contrast the evolution of baby transport – from pram to buggy!

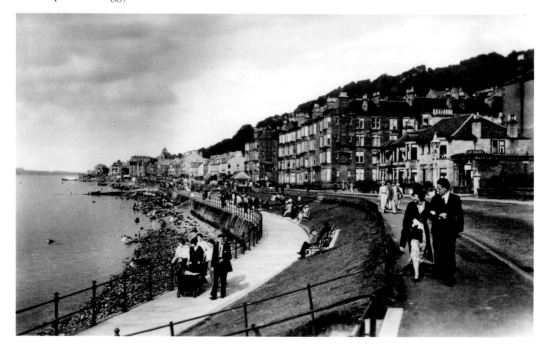

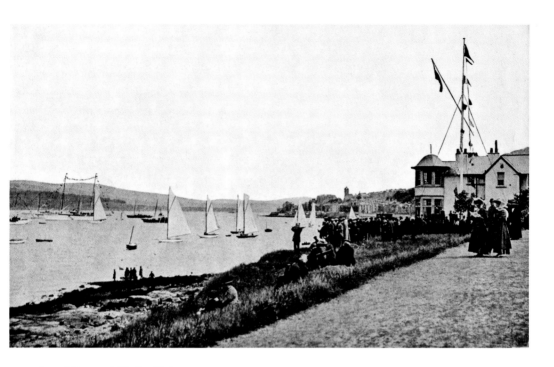

Royal Gourock Yacht Club
In the 100 years or so of elapsed time between these views, little has changed (except for ladies' fashion, of course!) and the clubhouse looks much as it did. It was largely funded by James Coats, owner of the thread mills in Paisley, and was officially opened on 28 February 1903. An extension on the side towards the camera has resulted in the flagpole having to be repositioned nearer the shore, where extra storage areas have been built.

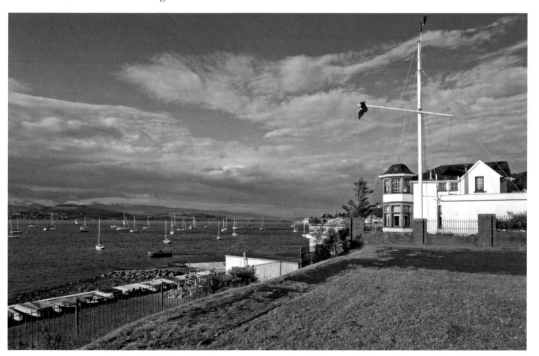

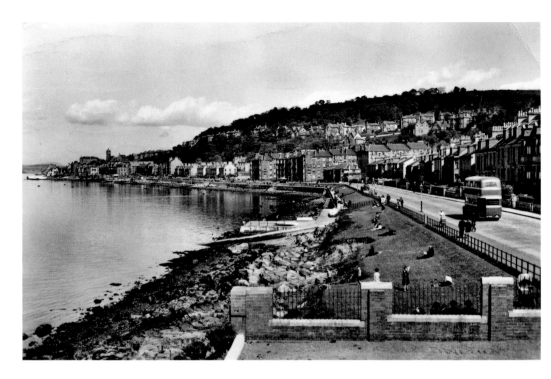

Ashton from the Yacht Club

Very little has changed in this view looking east towards the Gourock esplanade. The railings that appear in the view from around 1950 have been removed and the Yacht Club's car park has been extended, but otherwise the only differences are the inevitable cars and lamp standards that mar modern views.

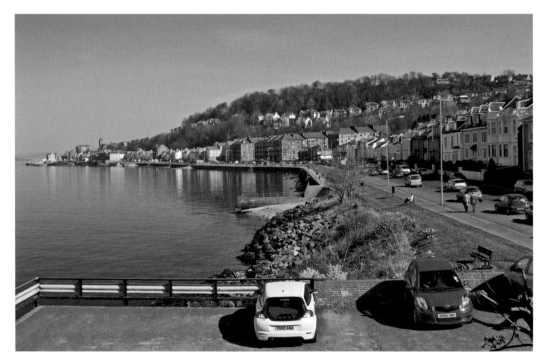

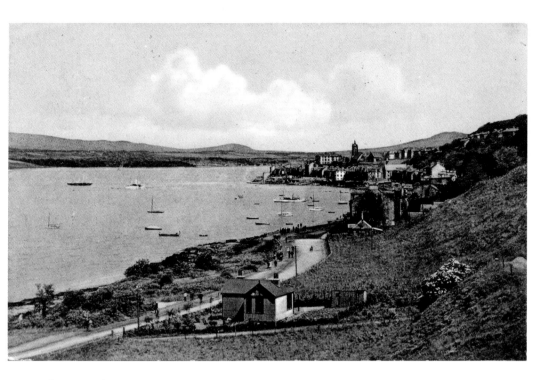

Ashton Road

This early view is undated, but was probably taken in the early 1900s. The coast road to the west out of Gourock is little more than a track and houses extend only as far as the Victoria Road junction. In contrast, the hillside today is covered by housing and the road is only just visible above the rooftops. The residential area now extends along the shore road for at least another mile to the west beyond this point.

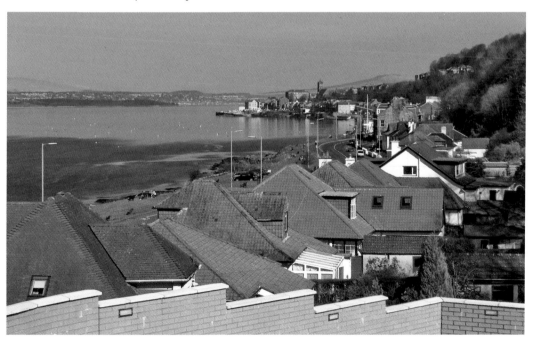

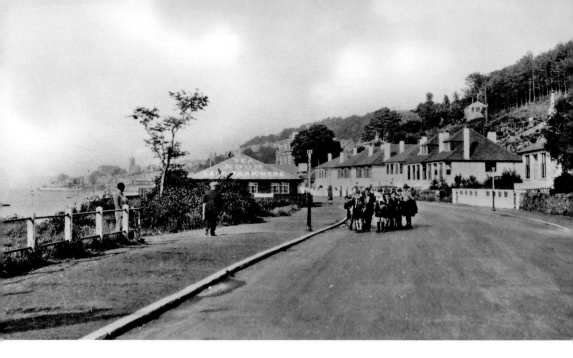

Cloch Road Looking East

Today, no trace of the 'TEA ROOM' remains, but 'CARS PARK HERE' is still accurate. The same houses, some a little modified, still stand and building has taken place on the hillside behind. The scout troop in the original picture appears to have been standing near where the 'BUS STOP' marking is today – perhaps they were even waiting for a bus back then. Modern traffic meant that using a viewpoint in the middle of the road was not a sensible option!

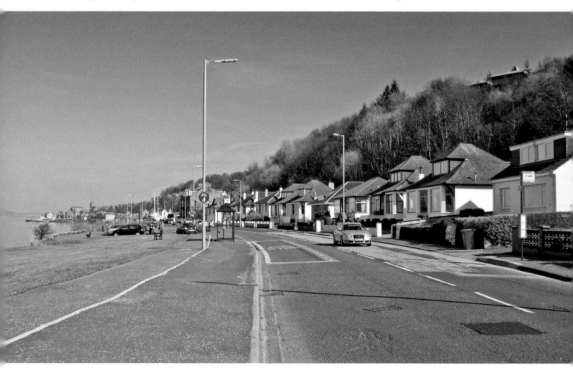

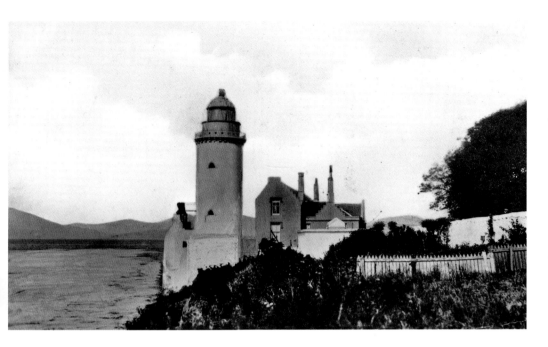

The Cloch Lighthouse

Even an apparently fixed feature, such as this well-known landmark, changes over time. In an early view, from around 1930, the tower is unadorned but has now achieved 'black belt' status! Tree growth now renders the original view impossible, but a position high on the shore affords almost the same perspective. 'The Cloch' (from the Gaelic word for stone) was built in 1797 to warn ships of the dangerous 'Gantocks' skerry. It looks at its best when warm evening light floods across the river from the direction of Dunoon.

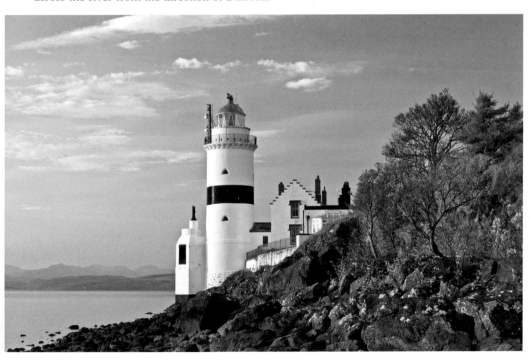

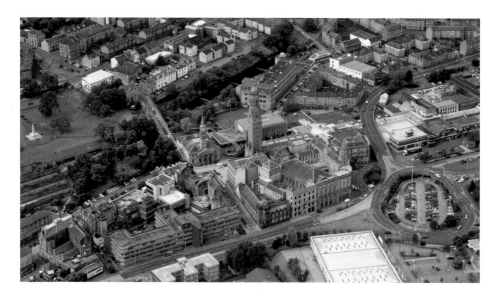

Greenock from the Air

A concluding aerial view centred on the Municipal Buildings shows the eastern end of the town centre as it is today – stretching from the Well Park memorial on the far left to the Oak Mall and the 'Bull-ring' roundabout on the right.

Acknowledgements

Early Photographs

Images appearing on the under-noted pages have been used courtesy of the following sources; all others are by the authors or have been reproduced from old postcards:

McLean Museum archive (thanks to Val Boa) – 6, 9, 12, 16, 17, 19, 22, 23, 25-27, 32, 33, 37, 41, 50, 51, 53, 54, 58, 59, 63, 67-72, 74, 77, 78, 81, 85 and 86. Also those on 18, 30, 34, 36, 48, 49, 52 and 55, which were taken by local photographer Eugene Mehat, whose pictures were donated to the archive by his family.

Gourock Community Council (thanks to Stuart Hunter) – 79 and 82. The photographers are unknown.

Royal Commission on the Ancient and Historical Monuments of Scotland – 24 and 45 (© RCAHMS. Licensor www.rcahms.gov.uk).

Alexander Bowers – 15, 20 (inset), 21, 29 and 40.

Bill Barry – 30 (inset) and 84 (inset).

Recent Photographs

These were taken by the authors themselves, with the exception of the aerial pictures on pages 45, 82 and 96, which are the work of Bill Barry.

Special thanks are due to the staff of Kincaid House care home for allowing access to take the picture on page 24.